ACQUISITIONS 1 9 7 3 · 1 9 8 0

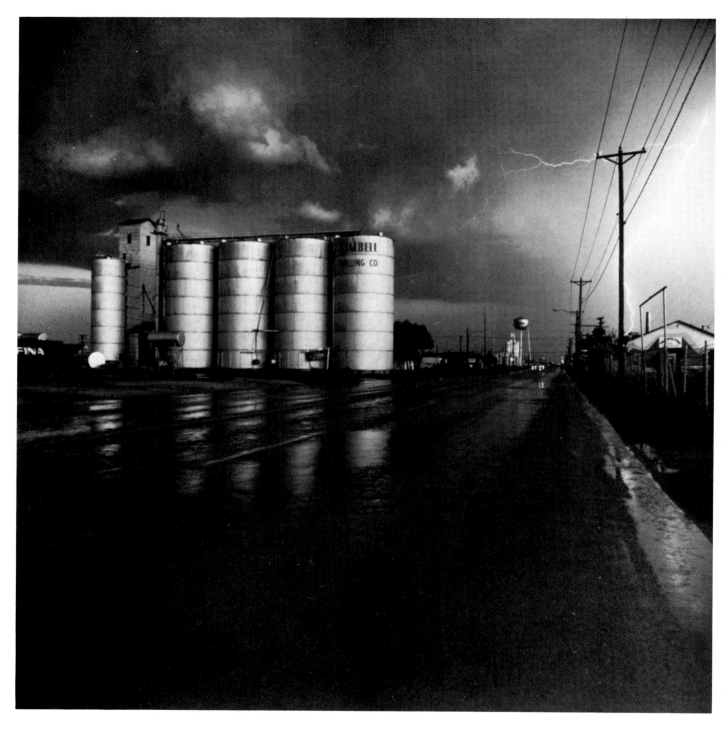

118. FRANK W. GOHLKE

Library of Congress Catalogue Card Number 81-81748 ISBN # 0-935398-02-3

ACQUISITIONS 1973 · 1980

ROBERT A. SOBIESZEK · MARIANNE FULTON · PHILIP L. CONDAX

GEORGE EASTMAN HOUSE

A museum may be identified by a number of its functions. Prominent among them is the maintenance of a collection of objects. The International Museum of Photography at George Eastman House is the guardian of four major collections; a photographic print and negative archive; photographic and cinematographic equipment; a film archive; and a library on photography and film. The holdings in each of these collections are extensive. Combined they make George Eastman House the major museum for such materials in the United States.

The dynamics of a museum, however, also depend upon the vitality of its collections—how they grow—how they are made available to the general public. Over the past eight years, the collections of George Eastman House have expanded significantly in numbers and continued to gain depth in their quality. Many of the important additions have been exhibited to the public as they were received. A major portion of the Sipley collection, acquired by a gift from the Minnesota Mining & Manufacturing Company in 1976, was presented in the exhibition *An American Century of Photography*, 1840–1940 in the summer of 1978. An important group of prints from the bequest of Edward Steichen, given to the Museum by direction of Joanna Steichen, formed *Steichen: A Centennial Tribute Exhibition* in the summer of 1979. A small version of the Steichen show was made into a traveling exhibit, part of the series of such exhibitions that George Eastman House makes available to museums, galleries, and other centers around the world. Most recently an exhibition of Paul Strand's portfolio *The Garden* was shown at the Museum; it was a gift from the Paul Strand Foundation, which was received in 1980.

The last exhibition of accumulated acquisitions mounted by George Eastman House was held in 1973. We are pleased to present this year highlights from the acquisitions of the Museum over the past eight years. This catalogue provides details on the approximately 300 photographic prints and 40 items of equipment displayed in the George Eastman House exhibition *Acquisitions 1973–1980*, to be held from June 12, 1981 to September 13, 1981. During part of this period of time, the Museum will also be showing in the Dryden Theatre acquisitions made by its Film Department during the same eight years.

The vast collections of George Eastman House are a rich national resource. Its Board of Trustees and staff believe in the importance of enriching those collections even further through thoughtful acquisition policies. We are also committed to presenting them to the public, hence this exhibition and catalogue.

I would like to point out, however, that what one will find in *Acquisitions 1973–1980* is the tip of the iceberg. More lies within George Eastman House. We hope in the future to share more and more of it with you.

Robert A. Mayer
Director

Above anything else, the International Museum of Photography at George Eastman House is the various collections it houses: photography, technology, and film. Each has its own very special strengths, shortcomings, and character. The materials in the collections are the texts with which the Museum educates and from which issue many of the exhibitions generated at the Museum. And it is by these collections that the Museum defines itself. The collections, however, are not bodies of materials lying in state, the mute inheritances of the past; rather, they are active sets of artifacts reflecting the past and addressing the present.

When the Museum opened in 1949, its nascent collections were, even then, something special in the photographic community. Since the very early years, each of the three collections—as well as the Museum's research library—has continued to expand through acquisition of new and differing artifacts of the distant and near past. This expansion was only in part the result of continuing pressure from an ever-changing and ever-broadening emphasis on the history of photography; it was also very importantly the result of a variety of dynamics internal to the collections themselves.

Any collection is a confrontation with history while at the same time an affirmation of the present. History is not something that was—it is and will be. For each of its viewers or participants it continually changes as do the needs it satisfies. History is never static; not only do interpretations change, but even the facts and their contexts. And just as no view of history is ever static enough to allow any collection to remain a precise analogue of the past for long, no vital collection stays immutable or exists in a vacuum. A collection is formed, to be

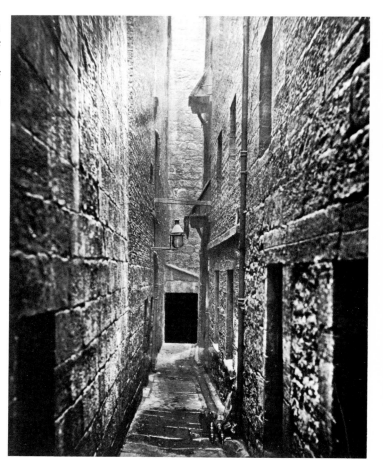

23. THOMAS ANNAN

sure, by the imperatives, tastes, and fortunes directly affecting its growth, but a responsible collection is also one that is ever responsive to its own process of formation. Every collection is a given view of history; change any part of that collection and that view of history is also affected. Conversely, have part of that history reinterpreted or modified, as constantly happens, and the collection assumes a different pose.

Collections can be either inventories or interpretations. When they are strictly defined by their own specific objects, their very urge to closure or completion tends to limit their value to mere facts. Collections are much more vital, however, when they are characterized not only by their artifacts, but by what those objects mean in conjunction with each other and how they relate to a greater fabric of ideas. The value of a collection like this rests in its resiliency in responding to questions of immediate import and its fluidity in suggesting questions not yet asked. The greatest collections are precisely those whose potential for revelation transcends their magnitude or thoroughness, for an interpretive collection capitalizes on its own openness and constantly revises itself in terms of ongoing thought.

By its very nature and mandated purpose, the photographic collection of the George Eastman House can be nothing other than interpretive. Its aims and scope preclude any pretense at completion. The more than five-hundred thousand images that make up this collection, although quite extensive by many standards, are only a selection, a symbolic gesture tracing the history of the art and science of that fairly modern of graphic arts, photography. Paramount among the Museum's chartered aims is the formation of a collection of artifacts pertinent to and illustrative of that history. One of the principal aims of the Museum has been to construct and continue to build such a collection that by its distinct array of particular examples most questions could be fruitfully posed if not answered in every detail. The range of materials collected, therefore, must be exceptionally broad yet carefully circumscribed by an internal logic.

The scope of the photographic collection is quite simply to collect the history of photographic image making without regard to any particular period, nationality, style or process. Photography is considerably older than a century and one-half, and it has never been the patrimony of any one nation or culture. Nor is any single style, technique, or process quintessentially photographic. Photography is fundamentally a graphology of light, and as with any type of writing it matters little whether it is cursive or printed, in ink or by pencil. Photography's significance is its forms, actual or translated, and its contents, directly captured or physically augmented. Its value, of course, resides in the ideas transmitted by these forms and contents and in the emotions they affect.

Knowing the aims of a collection and what its scope should be are, in theory, the motive forces behind any acquisition. The application of that theory, however, is most often determined by other factors. A collection as far ranging as this one will have perenially more areas that ought to be developed or reinforced than could possibly be addressed at once. Just what to acquire at a given moment or during a given period is as much a matter of plan as it is of choice. Random growth is easily accomplished by arbitrarily listing what is missing from the collection and then proceeding to acquire as best one can. A more rational expansion, on the other hand, would demand a concert between needs, choices, and the manner in which the collection grows. In principle, the identification of needs leads to choices about what to acquire. But the addition

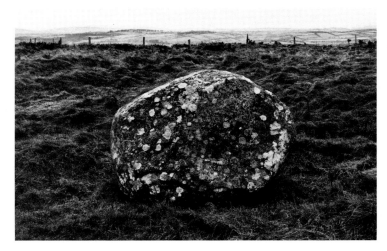

55. PAUL CAPONIGRO

of a new artifact or set of artifacts to a collection changes that collection. This change, in turn, redefines the collection as a whole, and with the redefinition, new needs are often made manifestly clear, leading to yet further additions, and so on. Frequently, a process like this is nearly impossible to discern, but it is endemic to the building of a collection.

Eight years ago, when the last "Acquisitions" show was exhibited, the Museum owned relatively few examples of what was to become an important pictorial concern of many younger photographers during the later 1970s. Characteristic of this style was an interest in architectural subjects and an approach to the subject that was clean, lucid, and analytical, as seen in the work of Lewis Baltz, Joe Deal, and Frank Gohlke. At the same time, in 1973, the collection lacked any of the great achievements of the nineteenth century photographers Thomas Annan and Henry Dixon, whose works share many of the same stylistic features with the newer photographs. It would be impossible to say with utter certainty that either group led to the notice or re-evaluation of the other, or that a totally independent factor may have guided the desire for both. It is also impossible to discount the fact that both groups were acquired at about the same time.

The resulting enrichment of the collection also cannot be dismissed; an enrichment in which a pictorial dialogue of sorts takes place across decades, nationalities, and diverse technical means. The value of a discourse like this lies not only in the apparent similarities but most especially in how the similar characteristics emphasize the differences of meaning and substance among the two groups, the various artists, and their historical periods. The end product, coincidentally, has been the dramatic strengthening of how the collection exemplifies major achievements in architectural photography–a new dimension to the entire collection and one that will demand recognition when it comes to future acquisition choices.

The mechanics of constructing a collection like that of the George Eastman House are not unlike those used for any collection. Since it is one thing to target

a need or desired artifact and quite another to locate the available object, acquisitions are most frequently a direct function of availability. The caprices of the market place as well as the personal tastes and interests of private collectors determine the options open to any collection's growth. And while the collection's magnitude or the coverage of its topic increases, the more difficult it is to aim at specific targets. The more the size of the collection grows, less of those items available to it become needed; and as the collection refines its holdings of major pieces, the more its demands become esoteric and more difficult to find.

Even with exigencies and limitations as these, the Museum has been very fortunate over the last eight years, as it had been over the previous quarter century, in terms of adding significantly to the collection. In fact, the past eight years have been one of the richest periods of meaningful expansion since the Museum was founded. The acquisition of private collections like those of Louis Walton Sipley or the Wadsworth Library, or of estates such as those of Edward Steichen or Paul L. Andersen are perhaps the most momentous of recent additions and, following earlier collections like those of Gabriel Cromer, Alden Scott Boyer, and Zelda MacKay, ones which most affect the general collection by their own particular flavors and emphases. These changes, in turn, have been augmented by small purchases and individual donations, by special funds for more extensive acquisitions, by assistance grants from governmental agencies, and by bequests and gifts of various types. All of these mechanics, as it were, have helped expand the collection well beyond the size it was in 1973; at the same time, of course, they have helped give the collection a far different complexion and tone.

All areas and periods of the history of photography within the collection have been radically affected by the acquisitions made between 1973 and last year. During this period of activity, the Museum acquired a spectacular American daguerreotype panorama, Julia Margaret Cameron's two-volume set of the *Idylls of the King*, the so-called "Queen's Bible" made for Queen Victoria and illustrated by Francis Frith, and all but one of its photographic work by Thomas Annan. Similarly, the Museum managed to obtain a large collection of major Italian views of the nineteenth century, Bool and Dixon's set of carbon prints made for the Society for Photographing Relics of Old London, all of its portraits by Franz Hanfstaengl, and major albums of images by the Bonfils, the Abdullah Brothers, and Edouard-Denis Baldus. With respect to turn of the century photography, important acquisitions were made of the late work of Peter Henry Emerson, F Holland Day's *The Seven Last Words* printed by Frederick Evans, portraits by Elias Goldensky, a large collection of Paul L. Anderson's pictorialist work, a number of autochromes by Edward Steichen, and a series of Newfoundland images by Gertrude Käsebier.

While every addition is in some way notable, specific mention might also be made of the printed photomontages by John Heartfield, many of Edward Steichen's later works including his experimental abstractions, a selection of Edward Curtis's gravures, a number of large works by Aaron Siskind, and prints by Ansel Adams, Anton Bruehl, Harry Callahan, Lee Friedlander, Nickolas Muray, and Edouardo Paolozzi. Aided by grants from the National Endowment for the Arts and matching funds from a sympathetic private sector, the collection has continued yearly to increase its holdings of living American photographers

like Paul Caponigro, Robert Heinecken, and André Kertész, as well as works by such artists as Robert Adams, Linda Connor, Frank Gohlke, John Gossage, Harold Jones, and Carla Steiger-Meister. Needless to say, not every important acquisition can be named in this space; the above is a very general list meant only to give an idea of the collection's range and variety. There have been many other photographers, both deceased and alive, whose work was acquired by the Museum; other names can be found in the catalogue checklist. Furthermore, a selected listing of acquisitions like this would be a bit like name dropping at a cocktail party for photographic historians were it not for the fact that an exhibition such as *Acquisitions 1973–1980* is designed precisely to highlight the collection's treasures.

In essence there is little difference between the act of giving a single heirloom found in an attic and the donation of an entire photographic collection. Each donor has contributed to the building of a collection he or she believes in, and that faith is something to be honored. Every gift made to a collection, each donation or bequest, no matter what its size or number, is a part of an ongoing creation of history and therefore a serious gesture of benefaction to the future. The various individuals and industries who donated single photographs, funds for acquisition, or literally thousands of prints to the collection have each left a legacy for a future beginning now. The names of those benefactors who assisted the collection over the last eight years are far too many to ennumerate here. Nor would it be fair to single out some at the expense of others; they are all to be thanked for their concern and spirit of generosity. Their names, however, are included in the checklist along with the identification of their exhibited gifts.

Acquisitions 1973–1980 is an exhibition motivated by a desire to share the collection's constant efforts at self-review with a public audience. What is included in the exhibition is not a history of photography, although it could stand as one. Nor is it a premeditated attempt at revisionist history, even though it is hoped that much of what is displayed will test the expectations of the cogniscenti while delighting the uninitiated. Constant revision shapes history; attitudes, values, styles, and tastes alter over time and innovative research techniques generate new ideas from what is left of the past. New or previously ignored artists are discovered or revived, a variety of historical subjects and styles are reinvestigated, and all are found to have merits previously clouded by less than receptive ideals. At the same time, the old "masters" (both male and female) seem to survive with the sustained persistance of quality while their achievements and greatness are not only reinforced, but actually enriched by every revision. In this light, therefore, the exhibition contains as many obscure and unexamined names as it does those who have become members of a photographic Pantheon; and a number of so-called "golden chestnuts" are presented along with some much less familiar images. It is hoped that each in turn will affect the perception and appreciation of the other.

Like the criteria used for the acquisition of this material, those used for the selection of the exhibition were diverse. And like the ultimate criterium in choosing an acquisition, the consummate and overriding ideal informing the exhibition has been that of sheer quality. Finally, the exhibition is not didactic for the expressed purpose of letting the complex visual richness of the works displayed be simply enjoyed.

Robert A. Sobieszek
Director
Photographic Collections

Marianne Fulton
Assistant Curator
Photographic Collections

328. W. & S. JONES

The extensive holdings of the George Eastman House equipment collection represent more than two centuries of the pre-history and history of photography. A collection of this type is never complete. The Museum has the responsibility of constantly studying and refining the collection while, at the same time, avoiding the temptation to divide material arbitrarily into historical and contemporary sections. Technological change is an ongoing evolutionary process making such a division meaningless; the moment a new product enters the marketplace it becomes a link in this historic chain. Understanding this process is the essential first step in the establishment of a rational collecting policy. A collection should contain a broad selection of equipment representative of the mainstream of any period, as well as significant specialized products however limited their distribution. The task is to identify what is important and take the necessary steps to place it in the permanent collection.

During the period 1973–1980 additions to the equipment collection were made by gift, purchase, and exchange. Overall, gifts from corporate and individual donors were by far the most important sources of material. A Hasselblad system including a sample of one of the special cameras built under contract for NASA's space program is featured in the exhibit. The Olympus Optical Company of Japan presented the Museum with an extensive collection of their current cameras and accessories. Both the Hasselblad and the Olympus systems are regularly on permanent display in the Mees Gallery. In 1979 the Bausch & Lomb Optical Company gave the Museum an important collection of lenses and shutters that had been a part of that company's patent museum. This collection is represented in the *Acquisitions 1973–1980* by a Petzval-type portrait lens made in 1890. Many other manufacturers and importers have also responded generously over the years to our requests for specimens of their latest products.

In recent years the equipment collection has been enriched as well by numerous important private gifts. The 35mm Bell & Howell motion picture camera used by James Sibley Watson, Jr. between 1928 and 1940 for a number of his avant-garde films is one of the many gifts Dr. Watson has given to the Museum in the past few years. A miniature stereo panoramic camera designed and built by the late Douglas Crockwell, Sr. was a gift of the inventor's family. A very rare motion picture projector that was on the market very briefly in the early 1920's was given to the Museum by S. Franklin Spira of New York. This unusual instrument projected images from a flexible disc; called the "Spirograph," it was a fascinating attempt to break away from traditional motion picture systems.

The equipment collection has been able to draw on a supply of valuable duplicate material to make a number of useful exchanges that have enriched the collection. The Vega Telephoto Camera and the Stereo Physiograph are just two exceptional items obtained by exchange.

To a lesser extent the collection is augmented by purchase. The very high prices of prime material necessarily limit what can be acquired in this manner. Nevertheless, a number of important pieces such as the beautiful Adams Minex Tropical Camera and the Goldmann Stereo Detective Camera, to name only two, were purchased.

Over the last eight years significant progress has been made in our goal to achieve a well rounded equipment collection.

349. VEGA SA

Philip L. Condax
Director
Technology Collections

NOTE ON THE CATALOGUE:

The 311 photographs and prints in the exhibition are listed in alphabetical order by the photographer's name or by that of the photographic firm. In cases where the name is not known the item is listed under "Unidentified Photographer." The second line of the catalogue entry indicates nationality and life dates. If the photographer was born in a country other than that listed as his or her nationality, this information is included within the parentheses with the life dates. The title of the piece appears on the third line. If the picture is not titled or no title has been discovered, a descriptive name has been given it and set off by squared brackets. The date of the photograph or print appears on the fourth line. Two dates, such as, 1942/1978, show the date of the negative followed by the date of the later print. The designation "From:" signals that the exhibited piece is part of a larger set, such as a portfolio, a series of photographs, a book, or an album. Dimensions are given in centimeters, height preceding width. The Museum's accession number is given for reference purposes. Provenance of the image appears on the last line.

Cameras and equipment are listed alphabetically by manufacturer. The manufacturer's city and country of origin appear in the second line. The third line indicates the proper name of the camera or piece of equipment, except when squared brackets are used to indicate an applied descriptive name. The item's generic type is the fifth line of information, followed by a description of the equipment's lenses where present. "Format" dimensions indicate the size of the resultant image; measurements are either in metric or English depending on the conventions used by the respective equipment's manufacturer. The Museum's accession number and the item's provenance complete the listing.

1
KEVORK ABDULLAH and WICHEN ABDULLAH
Armenian (firm active ca. 1859–1918)
TURKISH CEMETERY AT SCUTARY
ca. 1870s
From: album, *Constantinople ancienne & moderne*, Constantinople, 1869, fol. 59r.
Albumen print
22.8 x 30.2 cm.
77:005:59
Museum purchase
(Illustrated)

2
ANSEL ADAMS
American (1902–)
ANTELOPE HOUSE RUIN, CANYON DE CHELLY NATIONAL MONUMENT, ARIZONA, 1942
1942
From: A. Adams, *Portfolio VI*, New York, 1974, pl. 2
Gelatin silver print
49.9 x 39.1 cm.
74:059:2

Museum purchase with National Endowment for the Arts support

3
ANSEL ADAMS
CANYON DE CHELLE [sic], ARIZONA
1942
Gelatin silver print
37.5 x 46.5 cm.
73:035:2
Gift of the photographer
(Illustrated)

4
ANSEL ADAMS
EDWARD WESTON, CARMEL HIGHLANDS, CALIFORNIA, 1945
1945
From: A. Adams, *Portfolio VI*, New York, 1974, pl. 1
Gelatin silver print
49.6 x 37.0 cm.
74:059:1
Museum purchase with National Endowment for the Arts support

5
ROBERT ADAMS
American (1937–)
TRACT HOUSE, BOULDER COUNTY, COLORADO
1973
Gelatin silver print
15.2 x 19.3 cm.
77:149:2
Gift of the photographer

6
ROBERT ADAMS
TRACT HOUSES, LONGMONT, COLORADO, 1974
1974
Gelatin silver print
15.2 x 19.5 cm.
77:149:9
Gift of the photographer

7
ROBERT ADAMS
[TRACT HOUSES]
1974
Gelatin silver print
15.1 x 19.4 cm.
77:148:4
Museum purchase

8
ROBERT ADAMS
[TRACT HOUSES]
1974
Gelatin silver print
15.2 x 19.2 cm.

77:149:1
Gift of the photographer

9
GIUSEPPI ALINARI and
LEOPOLDO ALINARI
Italian (1836–1890 or 1892) and Italian
(?–1865)
FLORENCE: LOWER PART OF THE FIRST
DOOR BAPTISTRY
ca. 1854–1865
Albumen print
32.5 x 42.2 cm.
76:020:16
Museum purchase, ex-collection
 Wadsworth Library

10
GIUSEPPI ALINARI and
LEOPOLDO ALINARI
FLORENCE: PIAZZALE DEGLI UFFIZI
ca. 1854–1865
Albumen print
34.0 x 25.0 cm.
76:020:23
Museum purchase, ex-collection
 Wadsworth Library

11
GIOACCHINO ALTOBELLI E CI.
Italian (active Rome, ca. 1865–1878)
["NIGHT" VIEW OF THE ROMAN FORUM]
ca. 1865–1875
Albumen print
26.8 x 37.4 cm.
76:020:4
Museum purchase, ex-collection
 Wadsworth Library

12
GIOACCHINO ALTOBELLI E CI.
[UNIDENTIFIED RUINS]
ca. 1865–1875
Albumen print
26.9 x 37.6 cm.
76:020:5
Museum purchase, ex-collection
 Wadsworth Library

13
DOMENICO ANDERSON
British (b. Italy, 1854–1938)
TIVOLI: VILLA D'ESTE
ca. 1890s
Carbon print
25.5 x 19.3 cm.
74:099:26
Museum purchase

242. AARON SISKIND

14
JAMES ANDERSON [ISAAK ATKINSON]
British (1813–1877)
ROME: S. MARIA IN ARACOELI
ca. 1860s
Albumen print
19.3 x 25.8 cm.
76:202:349
Museum purchase, ex-collection
 Wasdworth Library

15
JAMES ANDERSON [ISAAK ATKINSON]
ROME: VIEW OF ST. PETER'S FROM
THE PINCIO
ca. 1860s
Albumen print
19.5 x 25.9 cm.
76:202:408
Museum purchase, ex-collection
 Wadsworth Library

16
PAUL L. ANDERSON
American (1880–1956)
BRANCH BROOK PARK
1911
Platinum print
20.0 x 14.7 cm.
76:315:70
Gift of Mrs. Raymond C. Collins
(Illustrated)

17
PAUL L. ANDERSON
DAHLIA
1933
Gelatin silver print
8.9 x 11.3 cm.
76:315:399
Gift of Mrs. Raymond C. Collins

18
PAUL L. ANDERSON
PORTRAIT OF UEGA
1911
Platinum print
34.5 x 26.3 cm.
76:315:418
Gift of Mrs. Raymond C. Collins

19
PAUL L. ANDERSON
[PORTRAIT OF UNIDENTIFIED WOMAN]
1911
Gum platinum print
23.0 x 27.5 cm.
76:315:413
Gift of Mrs. Raymond C. Collins

20
J. CRAIG ANNAN
Scottish (1864–1946)
LOMBARDY PASTORAL
1894
Photogravure print
6.3 x 17.8 cm.
74:109:1
Museum purchase

21
THOMAS ANNAN
Scottish (1829–1887)
CLOSE, NO. 148, HIGH STREET
1868–1877
From: Thomas Annan, *Photographs of
 the Old Closes, Streets, Etc. Taken
 1868–1877*, Glasgow, 1878, pl. 5
Carbon print
27.4 x 22.3 cm.
75:054:5
Museum purchase

22
THOMAS ANNAN
CLOSE, NO. 193, HIGH STREET
1868–1877
From: Thomas Annan, *Photographs of
 the Old Closes, Streets, Etc. Taken
 1868–1877*, Glasgow, 1878, pl. 9
Carbon print
27.3 x 23.0 cm.

75:054:9
Museum purchase

23
THOMAS ANNAN
CLOSE, NO. 61, SALTMARKET
1868–1877
From: Thomas Annan, *Photographs of
 the Old Closes, Streets, Etc. Taken
 1868–1877*, Glasgow, 1878, pl. 29
Carbon print
26.8 x 22.4 cm.
75:054:29
Museum purchase
(Illustrated)

24
RICHARD B. APPLEBY
American (active 1851–1859)
"CLASS OF 1857"
[UNIVERSITY OF ROCHESTER]
1857
Tintypes
36.5 x 64.5 cm. (21 Tintypes in one
 frame)
75:026:3
Gift of Miriam Rogachefsky

25
RICHARD AVEDON
American (1923–)

OSCAR LEVANT, PIANIST, BEVERLY HILLS,
CALIFORNIA, 4/9/72
1972
Gelatin silver print
38.2 x 38.2 cm.
76:047:2
Gift of the photographer
(Illustrated)

26
RICHARD AVEDON
IGOR STRAVINSKY, COMPOSER,
NEW YORK CITY, 11/2/69
1969
Gelatin silver print
24.4 x 59.4 cm.
76:046:1
Museum purchase with National
 Endowment for the Arts support

27
EDOUARD–DENIS BALDUS
French (1815–1882)
PAVILLON DE FLORE, FACADE FACING QUAI
ca. 1854
From: Hector Lefuel, *Palais du Louvre
 et des Tuileries, Motifs de décorations...*,
 (Ext.), Paris, 1854, pl. 15
Photogravure print
22.2 x 36.4 cm.
76:036:15
Museum purchase

28
EDOUARD–DENIS BALDUS
[PAVILLON SULLY]
ca. 1854–1855
From: album, *Paris*, Paris, no date
 (n.d.), (ca. 1850s), fol. 27r.
Albumen print
44.5 x 34.6 cm.
74:058:27
Museum purchase
(Illustrated)

29
EDOUARD–DENIS BALDUS
[SCULPTURAL MONUMENTS ON
THE ARC DE TRIOMPHE, PARIS]
ca. 1854–1860
From: album, *Paris Photographié*, Paris,
 n.d., (ca. 1850s), fols. 4v., 5r.
Albumen prints
27.5 x 18.7 cm. (4 verso)
27.6 x 19.9 cm. (5 recto)
76:312:8-9
Museum purchase

94. HENRY DIXON

30
LEWIS BALTZ
American (1945–)
SAN FRANCISCO, 1973
1973
Gelatin silver print
15.2 x 22.5 cm.
74:152:1
Museum purchase with National
 Endowment for the Arts support

31
HERBERT BARRAUD
British (active 1865–1890s)
THE MARCHIONESS OF GRANBY
1888
From: H. Barraud, *Men and Women of
 the Day*, London, 1888, p. 97
Woodburytype print
24.5 x 17.4 cm.
76:084:25
Museum purchase
(Illustrated)

32
THOMAS BARROW
American (1938–)
FILMS
1978
Photolithographic print
33.5 x 46.0 cm.
80:779:1
Museum purchase with National
 Endowment for the Arts support

33
HERBERT BAYER
American (b. Austria, 1900–)
GLASS EYES
1929
Modern gelatin silver print by Michaela
 Allan Murphy (from original
 negative), 1978
22.9 x 30.3 cm.
78:071:141MP
Gift of the photographer

34
HERBERT BAYER
PONT TRANSBORDEUR, OVER MARSEILLES
1928
Modern gelatin silver print by Michaela
 Allan Murphy (from original
 negative), 1978
20.2 x 31.0 cm.
78:071:113MP
Gift of the photographer

35
ANTONIO BEATO
British (?) (b. Italy, 1860s–1890s)
[DETAIL OF COLUMNATION,
GREAT TEMPLE, ESNE]
ca. 1870s
Albumen print
38.8 x 26.3 cm.
76:020:1
Museum purchase, ex-collection
 Wadsworth Library

36
FELICE BEATO
British (b. Italy, active 1855–1870s)
THE CAPTURE OF FORT TAKU IN
NORTH CHINA
1860
Albumen print
24.2 x 31.5 cm.
75:034:4
Museum purchase
(Illustrated)

37
CECIL BEATON
English (1904–1980)
PAULA GELLIBRAND, COUNTESS DE MAURY
ca. 1930
Gelatin silver print
44.7 x 35.4 cm.
73:190:4
Museum purchase
(Illustrated)

38
**ALEXANDER BECKERS and
VICTOR PIARD**
American (firm active late 1840s)
[STATUE]
ca. 1851
Daguerreotype
Stereograph, 8.1 x 17.1 cm. (ensemble)
77:246:9
Gift of 3M Co., ex-collection Louis
 Walton Sipley

39
CHARLES BIERSTADT
American (ca. 1832–1903)
[NIAGARA FALLS]
1867
Albumen print
18.0 x 24.2 cm.
77:294:5
Gift of 3M Co., ex-collection
 Louis Walton Sipley

40
MICHAEL BISHOP
American (1946–)
[WHITE PICKET FENCE, FLOWERING BUSH]
1977
Color coupler print
30.2 x 45.8 cm.
77:500:1
Museum purchase with National
 Endowment for the Arts support

41
**AUGUSTE–ROSALIE BISSON and
LOUIS–AUGUSTE BISSON**
French (1826–1900) and French
 (1814–1876)
[CHATEAU D'HERMIERES]: SAME FACADE
WITH SUNLIGHT EFFECT
ca. 1858
From: presentation album (to F.
 Baciocchi from Ed. Renaud), no
 title, Paris, 1858, fol. 13r.
Albumen print
31.3 x 45.7 cm.
77:405:13
Museum purchase
(Illustrated)

42
FELIX BONFILS
French (1831–1885)
BALBEK: RUIN OF WALL OUTSIDE
THE TEMPLE OF JUPITER
ca. 1870–1875
From: album, *Palestine and Syria*, no
 place (n.p.), n.d., (ca. 1870s),
 fol. 65r.
Albumen print
22:7 x 28:3 cm.
74:196:65
Museum exchange
(Illustrated)

41. AUGUSTE–ROSALIE and LOUIS–AUGUSTE BISSON

43

FREDERICK BREHM
American (ca. 1871–1950)
[CHURCHYARD]
ca. 1909
Gelatin silver print, hand colored
16.9 x 23.9 cm.
74:057:17
Gift of John Gibson

44

FREDERICK BREHM
[LANDSCAPE WITH SHEEP]
1909
Gelatin silver print, hand colored
18.9 x 23.9 cm.
74:057:19
Gift of John Gibson

45

C. W. BRIGGS COMPANY
American (firm est. 1871)
[ASCENDING CHRIST]
ca. 1875
"Slip Slide," painted glass, wood, steel
7.5 cm. dia.
77:804:1
Gift of 3M Co., ex-collection Louis
 Walton Sipley

46

SAMUEL BROADBENT
American (1810–1880)
[PORTRAIT OF UNIDENTIFIED MAN]
1856
Daguerreotype, hand colored
Quarter plate, 8.9 x 6.7 cm. (sight)
77:240:13
Gift of 3M Co., ex-collection Louis
 Walton Sipley

47

ANTON BRUEHL
American (b. Australia 1900–)
MARLENE DIETRICH
ca. 1937
Dye transfer print
33.0 x 26.0 cm.
76:093:1
Gift of the photographer
(Illustrated)

48

ANTON BRUEHL
[ADVERTISEMENT FOR WEBER and
HEILBRONER]
1929
Modern gelatin silver print by Michaela
 Allan Murphy (from original
 negative), 1975
24.3 x 19.5 cm.
76:095:10MP

Original negative gift of the
 photographer

49

ANTON BRUEHL
[ADVERTISEMENT FOR VAN RAALTE]
ca. 1936
Modern gelatin silver print by Michaela
 Allan Murphy (from original
 negative), 1975
24.0 x 19.0 cm.
76:095:4MP
Original negative gift of the
 photographer

50

HARRY CALLAHAN
American (1912–)
CUZCO
1974
Gelatin silver print
34.7 x 34.7 cm.
76:042:4
Museum purchase with National
 Endowment for the Arts support

51

HARRY CALLAHAN
CUZCO, #520
1974
Gelatin silver print
34.5 x 34.2 cm.
76:042:3
Museum purchase with National
 Endowment for the Arts support

52

JULIA MARGARET CAMERON
British (b. India, 1815–1879)
THE PARTING OF SIR LANCELOT AND
QUEEN GUINEVERE
ca. 1874
From: J. M. Cameron, *Illustrations to
 Tennyson's Idylls of the King and Other
 Poems*, vol. I, London, 1875, pl. 8
Albumen print
34.7 x 28.6 cm.
74:087:9
Museum purchase

53

JULIA MARGARET CAMERON
"FOR I'M TO BE THE QUEEN O' THE MAY,
MOTHER. I'M TO BE QUEEN O' THE MAY."
1874
From: J. M. Cameron, *Illustrations to
 Tennyson's Idylls of the King and Other
 Poems*, vol. II, London, 1875, pl. 1
Albumen print
34.6 x 25.0 cm.
76:024:2
Museum purchase
(Illustrated)

54

PAUL CAPONIGRO
American (1932–)
CUMBERLAND STONE CIRCLE,
CUMBRIA, ENGLAND, 1978
1978
Gelatin silver print
33.5 x 48.3 cm.

81:057:4
Museum purchase

55

PAUL CAPONIGRO
KILGOWAN STONE CIRCLE DETAIL,
IRELAND, 1966
1966
Gelatin silver print
29.0 x 48.0 cm.
81:057:2
Museum purchase
(Illustrated)

56

HENRI CARTIER–BRESSON
French (1908–)
CHILDREN'S PARTY, JULY 6, 1976
1976
Gelatin silver print
24.0 x 35.5 cm.
73:115:1
Gift of Magnum Photos, Inc.
(Illustrated)

57

SAMUEL J. CASTNER
American (1843–1929)
[CHILDREN ON LAWN]
ca. 1910–1912
Platinum print
19.6 x 22.6 cm.
77:305:14
Gift of 3M Co., ex-collection Louis
 Walton Sipley

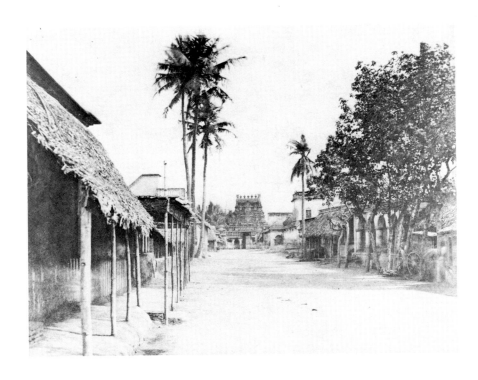

245. EDWARD STEICHEN

58
LYNNE COHEN
American (1944–)
SHRINERS, CHARLESTON, WEST VIRINIA
1973
Gelatin silver print
19.2 x 24.2' cm.
75:020:4
Museum purchase with Natonal
 Endowment for the Arts support

59
MARK COHEN
American (1943–)
[PEOPLE IN PHONE BOOTHS]
1978
Color coupler print
34.0 x 51.0 cm.
78:641:56
Gift of the photographer
(Illustrated)

60
JACK COLLINS
American (1888–)
[BOATS ON THE SEINE, PARIS]
ca. 1915
Gelatin silver print
27.2 x 34.6 cm.
76:280:26
Gift of the photographer

61
JACK COLLINS
[COUPLE WITH AUTOMOBILE]
ca. 1915
Gelatin silver print
27.1 x 34.5 cm.
76:280:2
Gift of the photographer

62
JACK COLLINS
[PARISIAN STREET; HORSE DRAWN CART]
ca. 1915
Gelatin silver print
27.0 x 34.5 cm.
76:280:22
Gift of the photographer

63
JACK COLLINS
[STREET SCENE; WOMAN WITH FLOWERS]
ca. 1915
Gelatin silver print
27.3 x 34.6 cm.
76:280:7
Gift of the photographer

64
WILL CONNELL
American (1898–1961)
PICKLED PEAR
1935
Dye transfer print
16.5 x 11.6 cm.
79:153:41
Gift of 3M Co., ex-collection Louis
 Walton Sipley
(Illustrated)

65
WILL CONNELL
[MAQUETTE FOR AUTOMOBILE
ADVERTISEMENT]
1935
Dye transfer print, montage
23.8 x 31.9 cm.
79:153:39
Gift of 3M Co., ex-collection Louis
 Walton Sipley

66
LINDA CONNOR
American (1944–)
[PYRAMID OF CANS]
1976
Gelatin silver print, gold toned
19.9 x 24.5 cm.
78:819:2
Museum purchase with National
 Endowment for the Arts support

67
LINDA CONNOR
[BOARD AGAINST WALL]
1973
Gelatin silver print, gold toned
20.0 x 25.0 cm.
79:145:1
Museum purchase with National
 Endowment for the Arts support
(Illustrated)

68
TOMMASO CUCCIONI
Italian (?–1864)
ROME: CLOISTER OF ST. JEAN LATERAN
Early 1860s
Albumen print
27.3 x 37.4 cm.
78:241:1
Gift of 3M Co., ex-collection Louis
 Walton Sipley

69
IMOGEN CUNNINGHAM
American (1883–1976)
SELF-PORTRAIT ON GEARY ST., 1958
1958
Gelatin silver print
22.5 x 20.0 cm.
79:2888:1
Museum purchase
(Illustrated)

70
HEINRICH CURSCHMANN
German (b. 1846, active 1890s)
DYSTROPHIA MUSCULARIS PROGRESSIVA
INFANTILIS, FAMILIARIS,
PSEUDOHYPERTROPHICA
1894
From: H. Curschmann, *Klinische
 Abbildungen...*, Berlin, 1894, pl. 2
Photogravure print by Meisenbach
 Riffarth & Co., Berlin
11.9 x 15.2 cm.
77:856:2
Museum purchase

71
HEINRICH CURSCHMANN
DYSTROPHIA MUSCULARIS PROGRESSIVA
INFANTILIS
1894
From: H. Curschmann, *Klinische
 Abbildungen...*, Berlin, 1894, pl. 6
Photogravure print by Meisenbach
 Riffarth & Co., Berlin
17.3 x 10.5 cm.
77:856:6
Museum purchase

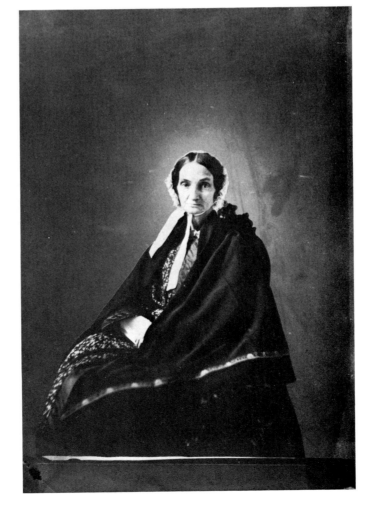

153. ANDRE KERTESZ

72

HEINRICH CURSCHMANN

DYSTROPHIA MUSCULARIS PROGRESSIVA
INFANTILIS (TYPE OF TRANSITION FROM
THE HORIZONTAL TO THE UPRIGHT
POSITION)

1894

From: H. Curschmann, *Klinische
Abbildungen...*, Berlin, 1894, pls. 8–9

Photogravure print by Meisenbach
Riffarth & Co., Berlin

54.5 x 7.7 cm.

77:856:8–9

Museum purchase

73

HEINRICH CURSCHMANN

COMPLETE LEFT-SIDED OCULO-MOTOR
DISABLEMENT

1894

From: H. Curschmann, *Klinische
Abbildungen...*, Berlin, 1894, pl. 39

Photogravure print by Meisenbach
Riffarth & Co., Berlin

11.0 x 15.3 cm.

77:856:39

Museum purchase
(Illustrated)

74

EDWARD CURTIS

American (1868–1952)

A BLACKFOOT TRAVOIS

ca. 1905

From: E. S. Curtis, *The North American
Indian...*, Cambridge, 1907–1930,
pl. 637

Photogravure print by Suffolk Eng.
Co., Cambridge

29.1 x 39.6 cm.

74:033:22

Museum exchange

75

EDWARD CURTIS

POMO SEED-GATHERING UTENSILS

ca. 1916

From: E. S. Curtis, *The North American
Indian...*, Cambridge, 1907–1930,
pl. 484

Photogravure print by Suffolk Eng.
Co., Cambridge

29.0 x 39.1 cm.

72:001:6

Museum purchase

76

EDWARD CURTIS

WICHITA GRASS-HOUSE

ca. 1905

From: E. S. Curtis, *The North American
Indian...*, Cambridge, 1907–1930,
pl. 654

Photogravure print by Suffolk Eng.
Co., Cambridge

28.8 x 39.1 cm.

72:001:35

Museum purchase

77

JUDY DATER

American (1941–)

TWINKA 1970

1970

Gelatin silver print

30.3 x 23.7 cm.

74:220:1

Museum purchase with National
Endowment for the Arts support

78

F. HOLLAND DAY

American (1864–1933)

"FATHER, FORGIVE THEM; THEY KNOW
NOT WHAT THEY DO."

1898

From: series, *The Seven Last Words*,
no. 1

Platinum print by Frederick Evans
from copy negative, 1912

19.9 x 15.1 cm.

73:027:1

Museum purchase
(Illustrated)

79

F. HOLLAND DAY

"TODAY SHALT THOU BE WITH ME
IN PARADISE."

1898

From: series, *The Seven Last Words*,
no. 2

Platinum print by Frederick Evans
from copy negative, 1912

20.0 x 15.2 cm.

73:027:2

Museum purchase
(Illustrated)

80

F. HOLLAND DAY

"WOMAN, BEHOLD THY SON;
SON THY MOTHER."

1898

From: series, *The Seven Last Words*,
no. 3

Platinum print by Frederic Evans from
copy negative, 1912

20.2 x 15.2 cm.

73:027:3

Museum purchase
(Illustrated)

81

F. HOLLAND DAY

"MY GOD, MY GOD, WHY HAST THOU
FORSAKEN ME?"

1898

From: series, *The Seven Last Words*,
no. 4

Platinum print by Frederick Evans from
copy negative, 1912

20.1 x 15.3 cm.

73:027:4

Museum purchase
(Illustrated)

47. ANTON BRUEHL

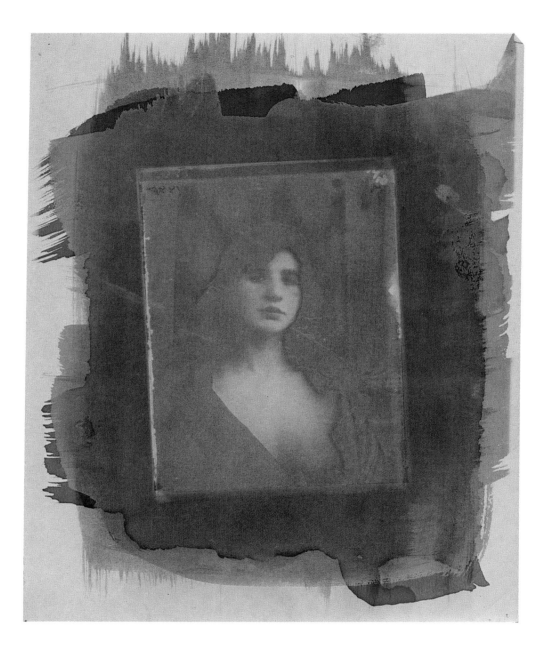

145. FREDERICK EUGENE IVES

82

F. HOLLAND DAY

"I THIRST."

1898

From: series, *The Seven Last Words*,
 no. 5

Platinum print by Federick Evans from
 copy negative, 1912

20.1 x 15.1 cm.

73:027:5

Museum purchase

(Illustrated)

83

F. HOLLAND DAY

"INTO THY HANDS I COMMEND MY SPIRIT."

1898

From: series, *The Seven Last Words*,
 no. 6

Platinum print by Frederick Evans
 from copy negative, 1912

20.2 x 15.1 cm.

73:027:6

Museum purchase

(Illustrated)

84

F. HOLLAND DAY

"IT IS FINISHED!"

1898

From: series, *The Seven Last Words*,
 no. 7

Platinum print by Frederick Evans
 from copy negative, 1912

20.1 x 15.2 cm.

73:027:7

Museum purchase

(Illustrated)

85

J. DAZIARO

Russian (active 1890s)

MOSCOW: THE KREMLIN SEEN FROM
MOSKVARETZKY BRIDGE

ca. 1890s

Albumen print, hand colored

20.9 x 26.5 cm.

77:852:1

Gift of Daniel Wolf Gallery

86

WARREN DE LA RUE

British (1815–1889)

FIRST TOTALITY PHOTOGRAPH, SECOND
TOTALITY PHOTOGRAPH. [and]
LITHOGRAPHIC FACSIMILIES

1860

From: W. De La Rue, *The Total Eclipse
 of July 18th 1860*, London, 1862,
 pls. 9, 9a

Lithographic print by J. Basire;
 albumen copy prints by Cundall and
 Downes

12.4 x 12.5 cm. (approx., each image)

76:297:6–9

Museum purchase

87

BARON DE MEYER

French (1868–1946)

DINARZADE

1924

Gelatin silver print

24.1 x 19.1 cm.

75:034:1

Museum purchase

88

JOE DEAL

American (1947–)

UNTITLED VIEW (ALBUQUERQUE)

1975

Gelatin silver print

35.0 x 35.0 cm.

77:118:3

Gift of the photographer

(Illustrated)

89

PHILIP HENRY DELAMOTTE

British (1820–1889)

ROGER'S SEAT IN DUTCH GARDEN

ca. 1873

From: Princess Marie Liechtenstein,
 Holland House, I, London, 1874,
 facing p. 183

Woodburytype print

11.6 x 13.8 cm.

76:106:25

Museum purchase

90

ROBERT DEMACHY

French (1859–1938)

[LANDSCAPE]

ca. 1905

Oil print

14.9 x 20.9 cm.

77:213:1

Gift of 3M Co., ex-collection Louis
 Walton Sipley

91

ROBERT DEMACHY

[PROFILE OF UNIDENTIFIED WOMAN]

ca. 1905

Oil print

15.9 x 8.8 cm.

77:213:2

Gift of 3M Co., ex-collection Louis
 Walton Sipley

92

MINYA DIEZ–DUHRKOOP

German (1873–1929)

[PORTRAIT OF UNIDENTIFIED WOMAN]

ca. 1915

Platinum print

25.3 x 20.1 cm.

77:209:2

Gift of 3M Co., ex-collection Louis
 Walton Sipley

51. HERBERT BARRAUD

93

HENRY DIXON

British (1821–1916)

CANONBURY TOWER

1879–1886

From: Society for Photographing
 Relics of Old London, *Photographic
 Relics of Old London*, London, 1886,
 pl. 25

Carbon print

22.5 x 17.9 cm.

76:048:25

Museum purchase

94

HENRY DIXON

LITTLE DEAN'S YARD, WESTMINSTER

1879–1886

From: Society for Photographing
 Relics of Old London, *Photographic
 Relics of Old London*, London, 1886,
 pl. 61

Carbon print

18.0 x 22.5 cm.

76:048:61

Museum purchase
(Illustrated)

95

HENRY DIXON

WATER GATE OF YORK HOUSE

1879–1886

From: Society for Photographing
 Relics of Old London, *Photographic
 Relics of Old London*, London, 1886,
 pl. 69

Carbon print

18.0 x 22.5 cm.

76:048:69

Museum purchase

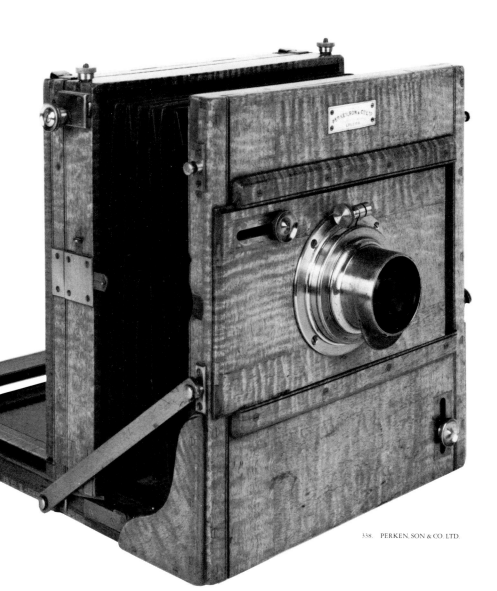

338. PERKEN, SON & CO. LTD.

96
HENRY DIXON
THE "OLD BELL," HOLBORN
1879–1886
From: Society for Photographing
Relics of Old London, *Photographic
Relics of Old London*, London, 1886,
pl. 86
Carbon print
22.9 x 17.7 cm.
76:048:86
Museum purchase

97
FRANTISEK DRTIKOL
Czechoslovakian (1878–1961)
[FEMALE NUDE]
ca. 1929
From: F. Drtikol, *Les Nus de Drtikol*,
Paris, 1929, pl. 2
Photogravure print by A. Calavas, Paris
28.5 x 22.3 cm.
74:115:2
Gift of Rudolf Skopec

98
MARCEL DUCHAMP
French (1887–1968)
[TWO CIGARETTES, UNPAPERED]
1936

From: Georges Huguet, *La Septième
face du dé*, Paris, 1936, deluxe
edition, supplemental cover
Gelatin silver prints, hand colored,
montage
29.3 x 21.5 cm. (cover)
77:848:1
Museum purchase

99
EDOUARD DURANDELLE
French (active 1860s –1880s)
EXTRUSION BENCHES
ca. 1875–1885
From: series, *Eschger Ghesquière & Cie.
Fondaries & Laminoirs de Biache St.
Vaast (Pas-de-Calais)*, unn.
Albumen print
44.8 x 53.8 cm.
78:693:1
Museum purchase
(Illustrated)

100
EDOUARD DURANDELLE
FURNACES
ca. 1875–1885
From: series, *Eschger Ghesquière & Cie.
Fondaries & Laminoirs de Biache St.*

Vaast (Pas-de-Calais), unn.
Albumen print
44.0 x 53.8 cm.
78:693:3
Museum purchase

101
EDOUARD DURANDELLE
SCHOOL FOR ORPHANS
ca. 1875–1885
From: series, *Eschger Ghesquière & Cie.
Fondaries & Laminoirs de Biache St.
Vaast (Pas-de-Calais)*, unn.
Albumen print
41.7 x 53.2 cm.
78:693:6
Museum purchase

102
PETER HENRY EMERSON
British (b. Cuba, 1856–1936)
"A STIFF PULL"
1886
From: London Stereoscopic &
Photographic Co., *A Selection of
Prize Pictures from the London
Stereoscopic and Photographic
Company's Amateur Photographic
Exhibition*, London, 1886, fol. 11r.
Albumen print
23.1 x 28.7 cm.
77:131:16
Museum purchase

103
PETER HENRY EMERSON
LEAFLESS MARCH
1888
From: P. H. Emerson, *Pictures of East
Anglian Life*, London, 1888, pl. 3
Photogravure print
24.5 x 23.3 cm.
77:550:3
Museum purchase

104
PETER HENRY EMERSON
A MARCH PASTORAL
1888
From: P. H. Emerson, *Pictures of East
Anglian Life*, London, 1888, pl. 12
Photogravure print
11.2 x 23.2 cm.
77:550:12
Museum purchase

105
PETER HENRY EMERSON
NORFOLK COTTAGES
1888
From: P. H. Emerson, *Pictures of East
Anglian Life*, London, 1888, pl. 28
Photogravure print
7.3 x 28.3 cm.
77:550:28
Museum purchase

106
PETER HENRY EMERSON
THE SNOW GARDEN
1895
From: P. H. Emerson, *Marsh Leaves*,
London, 1895, pl. 12
Photo-etching [photogravure print]
12.6 x 19.8 cm.
77:018:12
Museum purchase
(Illustrated)

107
WALKER EVANS
American (1903–1975)
ROADSIDE HOUSES FOR MINERS, VICINITY
BIRMINGHAM, ALABAMA, DECEMBER 1935
1935
Gelatin silver print
19.0 x 23.7 cm.
74:121:9
Museum purchase with National
Endowment for the Arts support

108
WALKER EVANS
ROADSIDE STORE BETWEEN TUSCALOOSA
AND GREENSBORO, ALABAMA
1936
Gelatin silver print
20.2 x 25.2 cm.
74:121:8
Museum purchase with National
Endowment for the Arts support

109
MARION FALLER and HOLLIS FRAMPTON
American (1941–) and American
(1936–)
SUNFLOWER RECLINING
(var.: "MAMMOTH RUSSIAN")
1975
Gelatin silver print
18.0 x 31.5 cm.
76:088:3
Museum purchase with National
Endowment for the Arts support

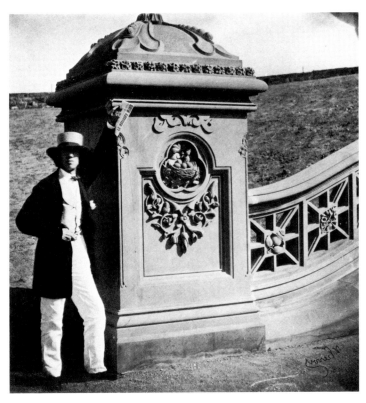

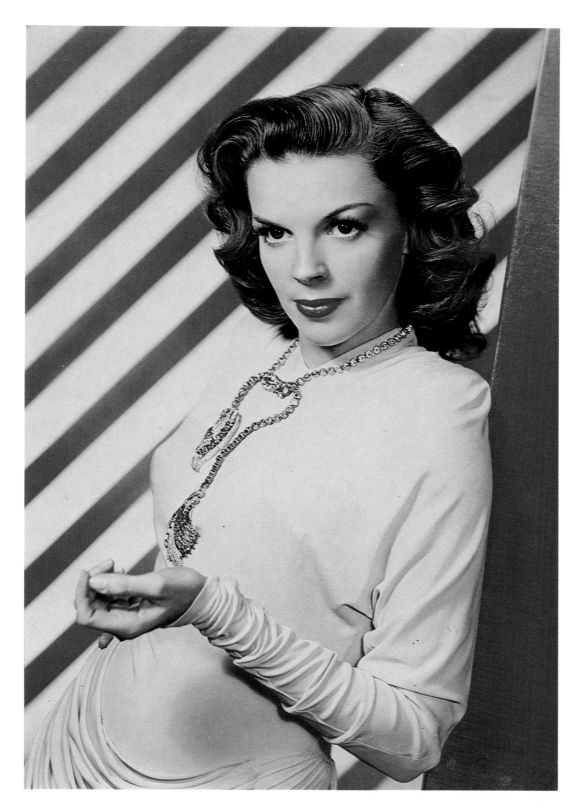

189. NICKOLAS MURAY

110
MARION FALLER and HOLLIS FRAMPTON
APPLE ADVANCING (var.: "NATHAN SPY")
1975
Gelatin silver print
18.0 x 31.5 cm.
76:088:16
Museum purchase with National
 Endowment for the Arts support

111
ROGER FENTON
British (1819–1869)
CHATSWORTH, THE PALACE OF THE PEAK,
THE ITALIAN GARDEN
ca. 1858–1860
Albumen print
33.8 x 43.8 cm.
75:123:2
Museum purchase
(Illustrated)

112
ROBERT FICHTER
American (1939–)
[ASTRONAUT STILL LIFE]
ca. 1974
Gum bichromate and cyanotype print
88.0 x 49.0 cm.
74:222:4
Museum purchase with National
 Endowment for the Arts support

113
LEE FRIEDLANDER
American (1934–)
PHILADELPHIA, PENNSYLVANIA 1965
1965
Gelatin silver print
27.8 x 35.3 cm.
77:272:1
Museum purchase with National
 Endowment for the Arts support

114
LEE FRIEDLANDER
POMONA, NEW YORK
1977
Gelatin silver print
18.5 x 27.7 cm.
77:272:5
Museum purchase with National
 Endowment for the Arts support

115
FRANCIS FRITH
British (1822–1898)
THE PYRAMIDS OF GEEZAH [sic]
ca. 1858
From: *The Holy Bible*, I, London, 1862,
 ("Queen's Bible"), facing p. 63
Albumen print
16.0 x 22.8 cm.
75:037:5
Museum purchase

116
TYRONE GEORGIOU
American (1947–)
[COLOR ABSTRACTION]
1975
Gum bichromate print with graphite
55.4 x 75.5 cm.
76:128:2
Museum purchase with National
 Endowment for the Arts support

117
FAY GODWIN
British (1931–)
TROYTOWN MAZE, SCILLY ISLES
ca. 1974
Gelatin silver print
17.5 x 17.5 cm.
80:292:4
Museum purchase

118
FRANK W. GOHLKE
American (1942–)
LANDSCAPE–GRAIN ELEVATOR AND
LIGHTNING–LA MESA, TEXAS, 1975
1975
Gelatin silver print
35.0 x 35.0 cm.
80:780:3
Museum purchase with National
 Endowment for the Arts support
(Illustrated)

119
ELIAS GOLDENSKY
American (b. Russia, 1868–1943)
[NUDE STUDY]
ca. 1926
Gum bichromate print
19.7 x 24.8 cm.
77:255:55
Gift of 3M Co., ex-collection Louis
 Walton Sipley

120
ELIAS GOLDENSKY
[PORTRAIT OF UNIDENTIFIED WOMAN]
ca. 1915
Gum bichromate print
24.7 x 19.8 cm.
77:116:759
Gift of 3M Co., ex-collection Louis
 Walton Sipley

121
ELIAS GOLDENSKY
[PORTRAIT OF UNIDENTIFIED WOMAN]
ca. 1915
Gum bichromate print
25.0 x 20.0 cm.
77:116:762
Gift of 3M Co., ex-collection Louis
 Walton Sipley

122
JOHN GOSSAGE
American (1946–)
HUNTINGTON GARDENS, CALIFORNIA, 1973
1973
Gelatin silver print
31.8 x 47.5 cm.
76:122:4
Gift of the photographer
(Illustrated)

123
EMMET GOWIN
American (1941–)
EDITH, DANVILLE, VIRGINIA, 1971
1971
Gelatin silver print
20.2 x 25.1 cm.
79:4311:1
Museum purchase with National
 Endowment for the Arts support

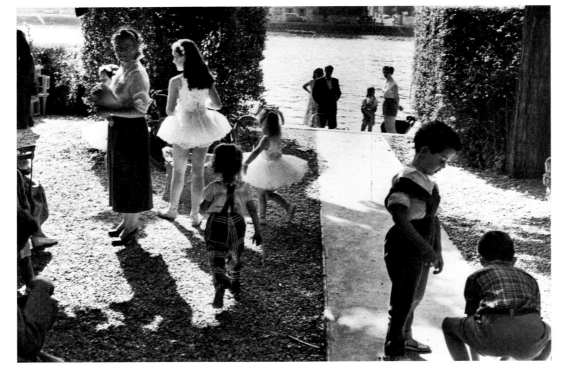

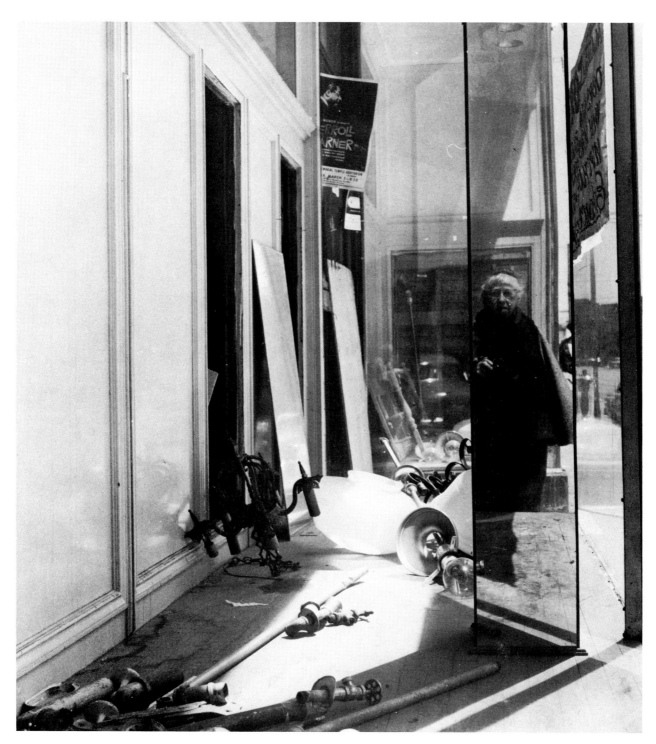

69. IMOGEN CUNNINGHAM

124
BETTY HAHN
American (1940–)
[BARNS WITH STITCHED RAINBOW]
1970–1971
Gum bichromate on fabric, with
 stitching
45.0 x 55.0 cm.
77:049:2
Museum purchase with National
 Endowment for the Arts support

125
GARY HALLMAN
American (1940–)
WINTER FOUNTAIN COVER #1
1971
Gelatin silver print
56.3 x 83.3 cm.
75:126:5
Museum purchase with National
 Endowment for the Arts support

126
FRANZ HANFSTAENGL
German (1804–1877)
[SELF PORTRAIT]
ca. 1853–1863
From: F Hanfstaengl, *Album der
 Zeitgenossen*, Munich, 1860, unn.
Albumen print
21.7 x 17.0 cm.
78:054:6

Museum purchase, Alliance Tool & Die
 Co. purchase fund

127
FRANZ HANFSTAENGL
CARL AUGUST STEINHEIL
1858
From: F Hanfstaengl, *Album der
 Zeitgenossen*, Munich, 1860, unn.
Albumen print
21.3 x 16.8 cm.
78:054:26
Museum purchase, Alliance Tool & Die
 Co. purchase fund
(Illustrated)

128
FRANZ HANFSTAENGL
FRANZ VON KOBELL
ca. 1853–1863
From: F Hanfstaengl, *Album der
 Zeitgenossen*, Munich, 1860, unn.
Albumen print
22.0 x 16.2 cm.
78:054:24
Museum purchase, Alliance Tool & Die
 Co. purchase fund

129
JOHN HEARTFIELD
German (1891–1968)
WHAT THE ANGELS OF CHRISTMAS

HAVE BECOME
1935
From: *AIZ*, December 26, 1935, p. 831
Photomechanical halftone of
 photomontage
39.0 x 27.0 cm.
76:076:29
Museum purchase
(Illustrated)

130
ROBERT HEINECKEN
American (1931–)
CLICHE VARY/FETISHISM
1974
Photographic emulsion on canvas,
 pastel chalk
106.7 x 106.7 cm.
76:012:1
Museum purchase with National
 Endowment for the Arts support

131
ALEXANDER HESLER
American (1823–1895)
[PORTRAIT OF CHARLEY FOSTER]
ca. 1856
Daguerreotype
Quarter plate, 9.4 x 6.9 cm. (sight)
77:390:1
Museum purchase

132
GEORGE W. HEWITT
American (1841–1916)
[FLOWER STUDY]
ca. 1900–1905
Platinum print
23.7 x 19.0 cm.
77:305:1
Gift of 3M Co., ex-collection Louis
 Walton Sipley

133
**DAVID OCTAVIUS HILL and
ROBERT ADAMSON**
Scottish (1802–1870) and Scottish
 (1821–1848)
MRS. BELL, MADRAS
1844–1845
Salted paper print
20.7 x 14.3 cm.
77:502:1
Gift of 3M Co., ex-collection Louis
 Walton Sipley

134
LEJAREN A HILLER
American (1880–1969)
[WAR BONDS CAMPAIGN]
ca. 1942
Gelatin silver print, composite
44.8 x 37.6 cm.
78:953:36
Gift of 3M Co., ex-collection Louis
 Walton Sipley

135
SIGISMOND HIMELY
Swiss (1801–1872)
IBSAMBOUL
1841
From: Hector Horeau, *Panorama
 d'Egypte et de Nubie*, Paris, 1841,
 unn.
Aquatint etching, colored (from
 daguerreotype by Joly de
 Lotbinière?), printed by Bougeard
28.3 x 40.6 cm.
78:701:1
Museum purchase

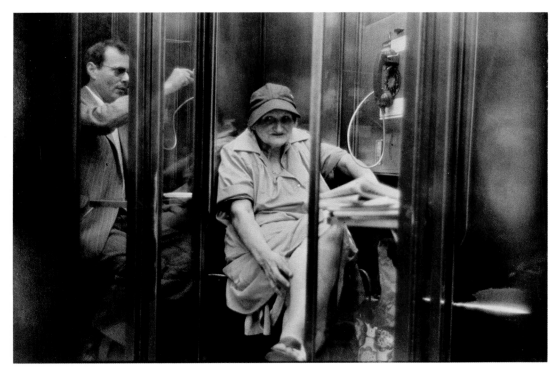

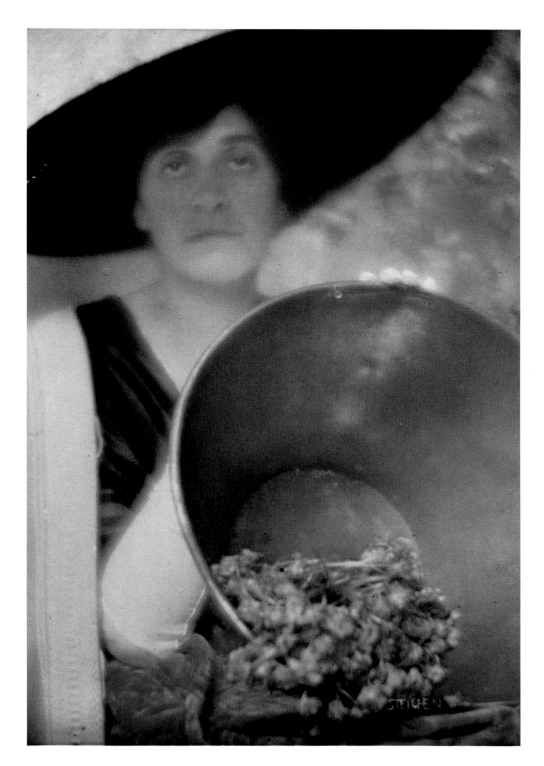

251. EDWARD STEICHEN

136
SIGISMOND HIMELY
DAKKE (above) [and] KORTI (below)
1841
From: Hector Horeau, *Panorama d'Egypte et de Nubie*, Paris, 1841, unn.
Aquatint etching, colored (from daguerreotypes by Joly de Lotbinière?), printed by Bougeard
20.0 x 28.5 cm. (above)
19.8 x 28.7 cm. (below)
78:701:2
Museum purchase

137
A. HORSLEY HINTON
British (1863-1908)
DAYS AWAKENING
1896
Platinum print
49.2 x 29.1 cm.
77:338:36
Gift of 3M Co., ex-collection Louis Walton Sipley

138
E. O. HOPPE
German (1878-1972)
[ADOLF BOLM AS THE PRINCE IN THAMAR]
ca. 1911
From: E. O. Hoppé, *Studies from the Russian Ballet*, London, 1911, unn.
Photogravure print
19.3 x 14.6 cm.
74:096:2
Museum purchase

139
E. O. HOPPE
[TAMARA KARSAVINA IN THE SPECTRE DE LA ROSE]
ca. 1911
From: E. O. Hoppé, *Studies from the Russian Ballet*, London, 1911, unn.
Photogravure print
19.2 x 13.8 cm.
74:096:7
Museum purchase

140
E. O. HOPPE
[VASLAV NIJINSKY AS THE GOLDEN SLAVE IN SCHEHERAZADE]
ca. 1911
From: E. O. Hoppé, *Studies from the Russian Ballet*, London, 1911, unn.
Photogravure print
19.3 x 13.4 cm.
74:096:11
Museum purchase

141
STEPHEN HORGAN
American (1854-1941)
SHANTY TOWN
1880
Electrotype from original single screen halftone engraving, copper over zinc on wood
11.0 x 17.0 cm.
77:090:1
Gift of 3M Co., ex-collection Louis Walton Sipley

142
GEORGES HUGNET
French (1906-1936)
THE DOUBLE LIFE
1936
From: G. Hugnet, *La Septième face du dé*, Paris, 1936, unbound, hors texte print to deluxe edition
Typographical and photomechanical halftone, montage
28.0 x 20.1 cm.
77:848:23
Museum purchase

143
(RICHARD P.) SANDY HUME
American (1946-)
[FOUR MEN IN WESTERN WEAR]
1977
Gelatin silver print
28.6 x 42.9 cm.
78:1065:2
Museum purchase with National Endowment for the Arts support

144
IKKO
Japanese (1931-)
NEW MEXICO, USA, 1972
1972
Gelatin silver print
27.7 x 41.5 cm.
74:128:1
Museum purchase

145
FREDERICK EUGENE IVES
American (1856-1937)
[COLOR EXPERIMENT]
ca. 1917

Gum albumen print
19.3 x 15.8 cm.
77:459:24
Gift of 3M Co., ex-collection Louis Walton Sipley
(Illustrated)

146
FREDERICK EUGENE IVES
[PORTRAIT OF UNIDENTIFIED WOMAN WITH PARASOL]
ca. 1917
Ives process print
23.0 x 18.5 cm.
77:459:170
Gift of 3M Co., ex-collection Louis Walton Sipley

147
CHARLES JOB
British (ca. 1853-1930)
NEAR CROWBOROUGH
1905
Screened carbon print
26.2 x 35.1 cm.
74:225:2
Museum exchange

148
HAROLD JONES
American (1940-)
TOWER
1978
Gelatin silver print
45.8 x 36.8 cm.
80:381:3
Museum purchase

149
HAROLD JONES
[SELF-PORTRAIT]
1978
Gelatin silver print
45.0 x 35.4 cm.
79:2989:1
Museum purchase

150
GERTRUDE KASEBIER
American (1852-1934)
THE COW YARD
1904
Gum bichromate print, triptych
15.6 x 36.0 cm. (ensemble)
74:215:1
Museum purchase

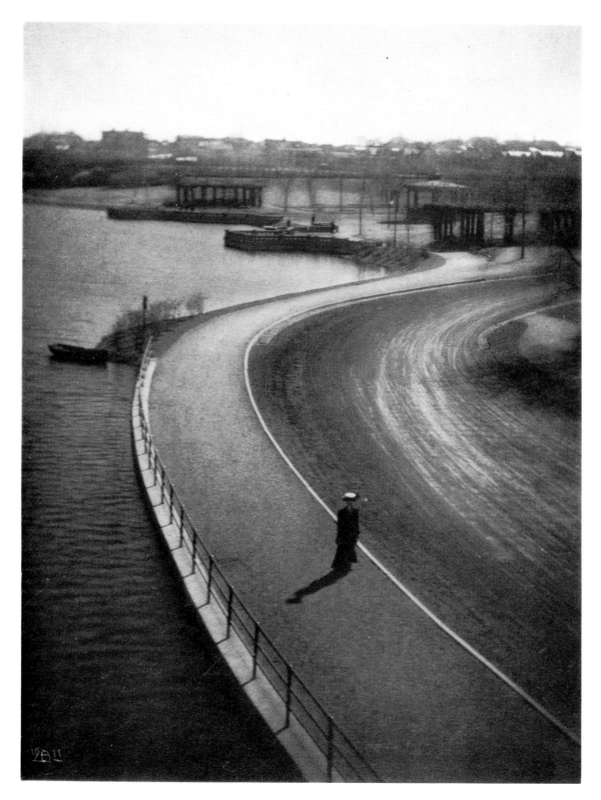

16. PAUL L. ANDERSON

151
GERTRUDE KASEBIER
WHARF RATS, PETTY HARBOUR
1912
Platinum print
19.0 x 23.9 cm.·
74:060:20
Gift of Mrs. H. Turner

152
GERTRUDE KASEBIER
[NETS AND DRIED FISH, NEWFOUNDLAND]
1912
Platinum and gum print
19.2 x 23.5 cm.
74:060:22
Gift of Mrs. H. Turner
(Illustrated)

153
ANDRE KERTESZ
American (b. Austria–Hungary,
 1894–)
JULY 6, 1976
1976
Gelatin silver print
24.0 x 34.8 cm.
80:806:4
Museum purchase with National
 Endowment for the Arts support
(Illustrated)

154
ANDRE KERTESZ
MARCH 20, 1978, NO. 8
1978
Gelatin silver print
18.3 x 24.9 cm.
80:806:1
Museum purchase with National
 Endowment for the Arts support

155
ANDRE KERTESZ
SZENT ENDRE, HUNGARY, AUGUST 3, 1975
1975
Gelatin silver print
27.3 x 34.9 cm.
80:804:3
Museum purchase with National
 Endowment for the Arts support

156
LES KRIMS
American (1943–)
[SELECTION FROM] ACADEMIC ART WORDS
1978
From: work, *Academic Art: 1975–1978*
Gelatin silver print, sepia toned
20.9 x 24.7 cm.
79:2897:12
Museum purchase with National
 Endowment for the Arts support

157
FRANK LA ROCHE
American (1853–1934)
FACE OF MUIR GLACIER, ALASKA
1886
Gelatin silver print
24.9 x 61.6 cm.
75:121:1
Museum purchase

158
**WILLIAM LANGENHEIM and
FREDERICK LANGENHEIM**
American (b. Germany, 1807–1874)
 and American (b. Germany,
 1809–1879)
CHROMASCOPES
Late 1860s
From: W. & F. Langenheim,
 Langenheim's Magic Lantern Pictures,
 n.p. (Philadelphia), n.d., unn.
Albumen prints
38.0 x 26.4 cm. (7.5 cm. dia. each
 image)
77:626:91
Gift of 3M Co., ex-collection Louis
 Walton Sipley

159
**WILLIAM LANGENHEIM and
FREDERIC LANGENHEIM**

[PORTRAIT OF UNIDENTIFIED WOMAN]
ca. 1850s
Salted paper print
21.5 x 16.0 cm.
77:633:3
Gift of 3M Co., ex-collection Louis
 Walton Sipley
(Illustrated)

160
[WILLIAM LANGENHEIM]
[PORTRAIT OF FREDERICK LANGENHEIM]
ca. 1850s
Waxed paper negative
22.3 x 17.9 cm.
77:633:7
Gift of 3M Co., ex-collection Louis
 Walton Sipley

161
J. LAURENT Y CIA.
French (firm active 1860s–1870s)
CORRIDA, FRASCUELO PERFORMING THE
MULETA (INSTANTANEOUS PHOTOGRAPH)
ca. 1865–1880
Albumen print
33.0 x 23.6 cm.
76:307:10
Museum purchase

162
J. LAURENT Y CIA.
CORDORA: DOOR OF FORGIVENESS
ca. 1865–1880
Albumen print
33.7 x 24.4 cm.
76:307:3
Museum purchase

163
J. LAURENT Y CIA.
SEVILLE: DOORS OF THE MAIN ALTER
SACRISTY, FORMERLY FROM THE SAGRAIO
(IN THE CATHEDRAL)
ca. 1865–1880
Albumen print
32.8 x 20.8 cm.
76:307:4
Museum purchase

R 56 Suma, near Kobe.

64. WILL CONNELL

164

HENRI LE SECQ

French (1818–1882)

[STAINED GLASS WINDOW, CHARTRES
CATHEDRAL]

1852/1870s .

From: H. Le Secq, *Fragments
d'architecture et sculpture de la
Cathédrale de Chartres...*, Paris, n.d.,
(ca. 1870s), unn.

L'encre grasse process (photogravure?)
print by Thiel ainé, Paris

34.8 x 24.9 cm.

79:2634:9

Museum purchase

165

HENRI LE SECQ

[JAMB FIGURES, CHARTRES CATHEDRAL]

1852/1870s

From: H. Le Secq, *Fragments
d'architecture et sculpture de la
Cathédrale de Chartres...*, Paris, n.d.,
(ca. 1870s), unn.

L'encre grasse process (photogravure?)
print by Thiel ainé, Paris

33.0 x 23.0 cm.

79:2634:15

Museum purchase

166

HENRI LE SECQ

[JAMB FIGURES, CHARTRES CATHEDRAL]

1852/1870s

From: H. Le Secq, *Fragments
d'architecture et sculpture de la
Cathédrale de Chartres...*, Paris, n.d.,
(ca. 1870s), unn.

L'encre grasse process (photogravure?)
print by Thiel ainé, Paris

35.1 x 25.3 cm.

79:2634:16

Museum purchase

167

HENRI LE SECQ

[SUNDIAL, CHARTRES CATHERDAL]

1852/1870s

From: H. Le Secq, *Fragments
d'architecture et sculpture de la
Cathédrale de Chartres...*, Paris, n.d.,
(ca. 1870s), unn.

L'encre grasse process (photogravure?)
print by Thiel ainé, Paris

34.3 x 23.7 cm.

79:2634:21

Museum purchase

(Illustrated)

168

STEPHEN LIVICK

Canadian (1945–)

[CHILD WITH 2 DOLLS]

1974

Gum bichromate print

54.0 x 43.3 cm.

76:039:1

Museum purchase

169

**LONDON STEREOSCOPIC AND
PHOTOGRAPHIC CO.**

British (active 1860–1900s)

HADDON

ca. 1891

From: London Stereoscopic &
Photographic Co., *Midland Railway,
England. London Terminus and
Midland Grand Hotel*, London, n.d.,
(ca. 1891), pl. 17

Carbon print

20.2 x 25.2 cm.

76:023:22

Museum purchase

170

PIRIE MACDONALD

American (1867–1942)

GEORGE W. RUSSELL

ca. 1927

Gelatin silver print

22.7 x 15.2 cm.

80:242:41

Gift of 3M Co., ex-collection Louis
Walton Sipley

171

PIRIE MACDONALD

GEORGE W. RUSSELL

ca. 1927

Gelatin silver print

22.4 x 15.2 cm.

80:242:44

Gift of 3M Co., ex-collection Louis
Walton Sipley

172

ROBERT MACPHERSON

Scottish (1811–1872)

ROME: A FOUNTAIN AND STONE PINES IN
THE VILLA PAMPHILJ-DORIA

ca. 1856–1865

Albumen print

23.7 x 39.0 cm. (oval)

77:376:4

Gift of 3M Co., ex-collection Louis
Walton Sipley

173

ROBERT MACPHERSON

ROME: GROTTO OF EGERIA

ca. 1856–1860

Albumen print

38.5 x 31.4 cm.

76:020:36

Museum purchase, ex-collection
Wadsworth Library

174

ROBERT MACPHERSON

ROME: PINES, VILLA PAMPHILJ-DORIA

ca. 1856–1865

Albumen print

40.0 x 30.1 cm.

76:202:113

Museum purchase, ex-collection
Wadsworth Library

(Illustrated)

175

ROBERT MACPHERSON

[ROME: UNIDENTIFIED VIEW]

ca. 1856–1860

Albumen print

28.2 x 40.0 cm. (oval)

76:020:30

Museum purchase, ex-collection
Wadsworth Library

176

ROBERT MACPHERSON

[ROME (?): UNIDENTIFIED VIEW]

ca. 1856–1860

Albumen print

23.3 x 40.5 cm.

77:399:1

Museum purchase

177

JOE MALONEY

American (1949–)

PARAMUS, N.J., 1978

1978

Color coupler print

33.0 x 41.6 cm.

78:617:3

Museum purchase with National
Endowment for the Arts support

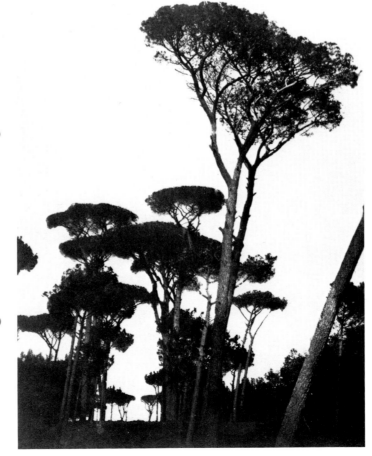

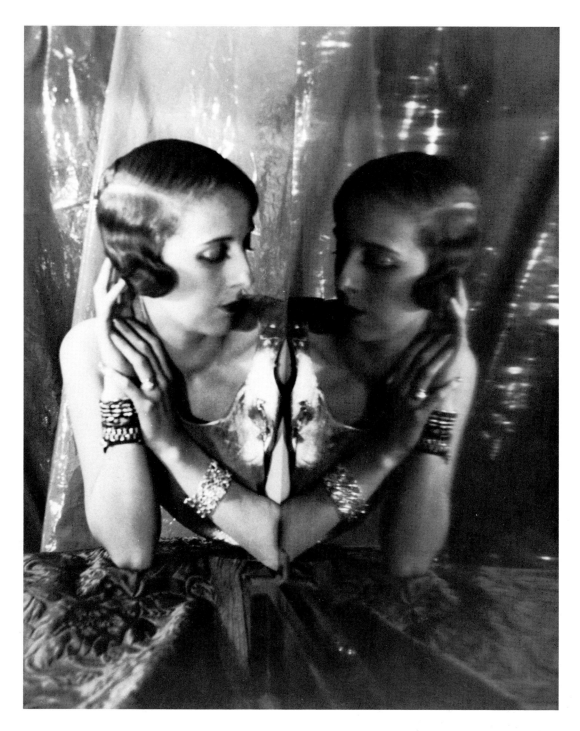

178
CHARLES MARVILLE
French (active 1852–1880)
MAYENCE SEEN FROM THE CHURCH OF
ST. ETIENNE
ca. 1852–1853
From: Blanquart-Evrard, Les Bords du
 Rhin, Lille, n.d. (1853)
Salted paper print
24.9 x 34.9 cm.
75:024:1
Museum purchase

179
A. MARGUET and A. DAUPHINOT
French (active 1870s) and French
 (active 1870s)
RHEIMS CATHEDRAL
ca. 1877
Photogravure print, Placet process;
 printed by Chatain, Paris
30.2 x 22.4 cm.
79:4407:1
Gift of Dr. Walter Clark

180
V. MASSE
French (active 1850s)
CELLULAR TANK CAR
ca. 1854
From: V. Masse, Chemin de fer de Paris à

Lyon, Paris, ca. 1855, fol. 15r.
Albumen print
21.2 x 29.9 cm.
73:010:14
Museum exchange

181
MELANDRI
French (active 1870s)
MLLE. BERNHARDT IN "RUY BLAS"
ca. 1879
From: *The Theatre*, London, II, No. 11,
 New Series (1 June 1879), pl. 21
Woodburytype print
11.5 x 7.4 cm.
79:4288:8
Gift of Dr. Walter Clark

182
ROGER MERTIN
American (1942–)
L.L.; BRIDGEHAMPTON, NEW YORK,
1977–1978
1977/1978
Gelatin silver print
20.0 x 25.5 cm.
78:769:2
Gift of the photographer
(Illustrated)

183
ROGER MERTIN
ROCHESTER, NY, 1974
1974
Gelatin silver print
21.8 x 32.7 cm.
75:060:2
Museum purchase with National
 Endowment for the Arts support

184
GARY METZ
American (1941–)
[5 POSTERIOR VIEWS OF MALE HEADS]
1977–1978
From: series, *Hair Piece*, 1977–1978
Gelatin silver prints
24.7 x 19.5 cm. (each print)
80:174:1–5
Museum purchase with National
 Endowment for the Arts support

185
[CHARLES HENRY MILLER]
American (1842–1922)
[CLOUD STUDY]
ca. 1880s, 1890s
Albumen print
19.2 x 26.8 cm. (irregular)
80:336:5
Museum purchase

186
BARBARA MORGAN
American (1900–)
DOUG WITH TOAD PRINCE
1944/1976
Gelatin silver print
24.9 x 28.1 cm.
76:170:1
Gift of the photographer

187
BARBARA MORGAN
MACY'S WINDOW
ca. 1939/1977
Gelatin silver print
24.2 x 34.2 cm.
79:4310:1
Museum purchase with National
 Endowment for the Arts support

188
GRANT MUDFORD
Australian (1944–)
LAS VEGAS, NEVADA
1975
Gelatin silver print
48.6 x 33.5 cm.
76:301:1
Gift of the photographer

189
NICKOLAS MURAY
American (b. Hungary, 1892–1965)
JUDY GARLAND
1945
Carbro print
39.0 x 27.1 cm.
77:100:14
Gift of 3M Co., ex-collection Louis
 Walton Sipley
(Illustrated)

190
NICKOLAS MURAY
EZIO PINZA
1946
Carbro print
31.2 x 43.3 cm.
77:100:3
Gift of 3M Co., ex-collection Louis
 Walton Sipley

191
FRANCES MURRAY
American (b. Ireland, 1947–)
DREAM CORD
1979
From: series, *Mysteries Series*, ca. 1979
Gelatin silver print
35.5 x 35.5 cm.
80:802:3
Museum purchase

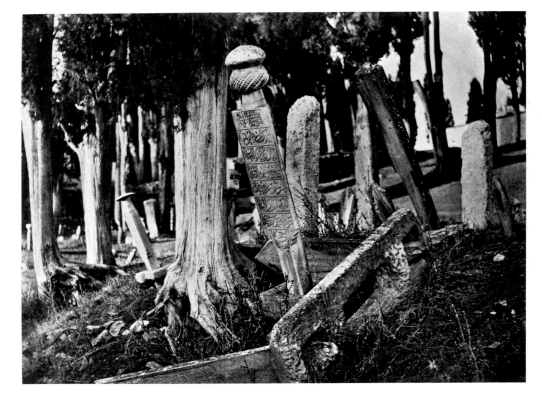

1. KEVORK and WICHEN ABDULLAH

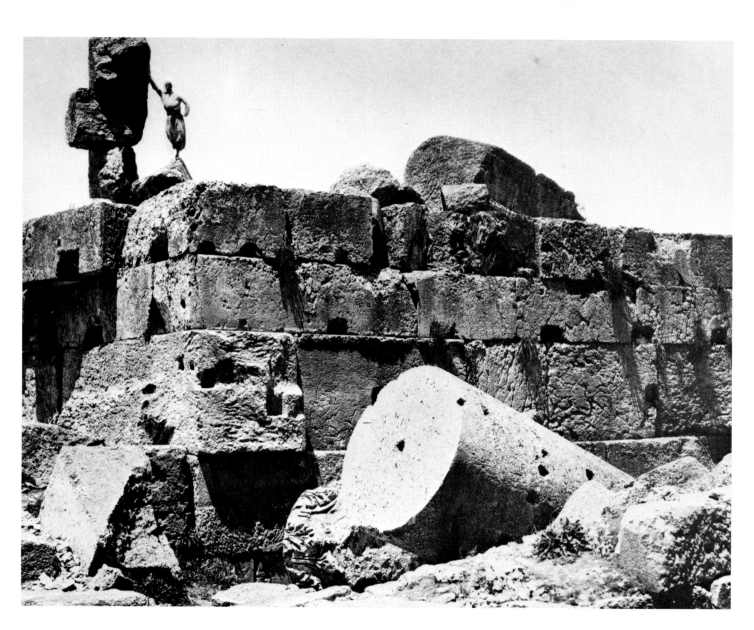

192
EADWEARD MUYBRIDGE
American (b. England, 1830–1904)
MAH-TA
1868
From: album, *Yo-sem-i-te California*, San
Francisco, n.d., (ca. 1868), fol. 9r.
Albumen print
20.2 x 14.7 cm.
78:1673:9
Gift of 3M Co., ex-collection Louis
Walton Sipley

193
EVELEEN MYERS
British (active 1890s)
[YOUNG WOMAN IN BIBLICAL COSTUME]
1890s
Platinum print
23.8 x 29.0 cm.
75:051:2
Museum purchase

194
NADAR (GASPARD FELIX TOURNACHON)
French (1820–1910)
EMILE AUGIER
ca. 1857–1860
From: series, *Les Figures
contemporaines* (?)
Photogravure print by Baudran and de
la Blanchere (?)
24.6 x 18.6 cm.
79:4402:3
Gift of Dr. Walter Clark

195
NADAR (GASPARD FELIX TOURNACHON)
LOUIS FRANCOIS VEUILLOT
ca. 1856–1860
From: series, *Les Figures contemporaines*
Photogravure print by Baudran and de
la Blanchere; printed by F.
Hadingue, Paris
25.0 x 18.9 cm.
79:4402:1
Gift of Dr. Walter Clark

196
ARTHUR NAGER
American (1949–)
[PINK HOUSE]
1977
Cibachrome print
16.0 x 23.6 cm.
77:380:1
Museum purchase with National
Endowment for the Arts support

197
**NATIONAL AERONAUTICS AND
SPACE ADMINISTRATION (N.A.S.A.)**
American (agency est. 1958)
[VOLCANIC EXPLOSION ON IO,
MARCH 13, 1979]
1979
Color coupler print
40.5 x 50.6 cm.
79:2913:3
Gift of Jet Propulsion Laboratory,
California Institute of Technology

198
**NATIONAL AERONAUTICS AND
SPACE ADMINISTRATION (N.A.S.A.)**
[JUPITER'S SATELLITE GANYMEDE,
MARCH 5, 1979]
1979
Color coupler print
40.5 x 50.7 cm.
79:2913:11
Gift of Jet Propulsion Laboratory,
California Institite of Technology

199
STABILIMENTO CARLO NAYA
Italian (active 1860s–ca. 1900)
THE SACCA ZENNARI AT PELLESTRINA
ca. 1887
From: C. Naya, *Isole della Laguna di
Venezia*, Venice, 1887, fol. 22r.
Albumen print
18.9 x 24.0 cm.
73:122:19
Museum purchase

200
BEA NETTLES
American (1946–)
[TOMATOES IN COLANDER]
1976
Kwik print
38.2 x 45.7 cm.
77:387:2
Museum purchase with National
Endowment for the Arts support

201
GIUSEPPE NINCI
Italian (1823–1890)
ROME: THE COLOSSEUM
ca. 1857–1860
Albumen print
60.4 x 153.4 cm.; 3 contiguous prints
76:207:1
Museum purchase, ex-collection
Mrs. Harper Sibley

202
FERDINANDO ONGANIA
Italian (active ca. 1869–1900s)
[DRAWING WATER FROM A WELL]
1891–1892
From: F. Ongania, *Calli e Canali in
Venezia*, Venice, 1900, portfolio
No. 2, pl. 16
Photogravure print
33.1 x 22.9 cm.
78:052:16
Museum purchase

203
FERDINANDO ONGANIA
[CANAL SCENE]
1891–1892
From: F. Ongania, *Calli e Canali in
Venezia*, Venice, 1900, portfolio
No. 5, pl. 50
Photogravure print
23.5 x 34.8 cm.
78:052:50
Museum purchase

 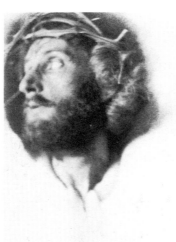 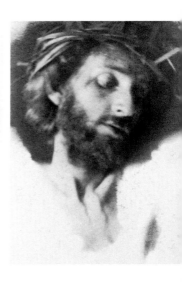

FERDINANDO ONGANIA
[CANAL SCENE]
1891–1892
From: F. Ongania, *Calli e Canali in Venezia*, Venice, 1900, portfolio No. 5, pl. 61
Photogravure print
14.4 x 23.2 cm.
78:052:61
Museum purchase

205
EDUARDO PAOLOZZI
Italian (1924–)
SKULL OF TEST DUMMY [and] USSR PROTON-SYNCHRON ELECTROPHYSICAL LABORATORY...VACUUM PUMPS TO THE ELECTROMAGNET
1971
From: E. Paolozzi, *Cloud Atomic Laboratory*, London, 1971, pl. B
Photo-etching
32.4 x 48.7 cm.
77:016:15,16
Museum purchase

206
EDUARDO PAOLOZZI
PUBLIC TORSO ON LORRY IN A MANHATTAN STREET FOR 'BOND CLOTHES FOR MEN' [and] VARGA-BILLBOARD-GIRL
1971
From: E. Paolozzi, *Cloud Atomic Laboratory*, London, 1971, pl. E

Photo-etching
18.3 x 43.8 cm.
77:016:13,14
Museum purchase

207
BRUCE PATTERSON
American (1950–)
[DESERT LANDSCAPE]
1975
Gelatin silver print
32.0 x 46.5 cm.
76:083:3
Museum purchase with National Endowment for the Arts support

208
JOHN PAUL PENNEBAKER
American (active 1930s)
CHICAGO WORLD'S FAIR
1933
Fresson prints, composite triptych
33.9 x 56.5 cm. (ensemble)
77:345:1
Gift of 3M Co., ex-collection Louis Walton Sipley

209
JOHN PFAHL
American (1939–)
LAKE ERIE SUNSET, OCT. 1976
1976
Color coupler print
35.5 x 43.3 cm.
79:143:1

Museum purchase with National Endowment for the Arts support

210
CARLO PONTI
Italian (active 1858–1875)
VENICE: THE BRONZE HORSES ABOVE THE BASILICA OF SAN MARCO
ca. 1860s
Albumen print
26.2 x 32.6 cm.
76:202:75
Museum purchase, ex-collection Wadsworth Library

211
CARLO PONTI
VENICE: PIAZZA DI SAN MARCO
ca. 1860s
Albumen print
25.9 x 32.1 cm.
76:202:6
Museum purchase, ex-collection Wadsworth Library

212
CARLO PONTI
VENICE: STAIRCASE OF THE GIANTS
ca. 1860s
Albumen print
32.1 x 26.4 cm.
76:202:96
Museum purchase, ex-collection Wadsworth Library

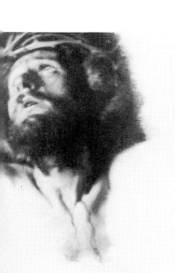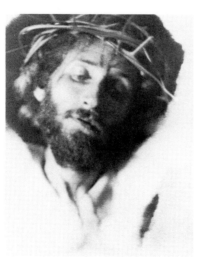

213
WILLIAM SOUTHGATE PORTER
American (1822–1889)
FAIRMOUNT WATER WORKS
1848
Daguerreotype panorama
8 half plates, trimmed; 36.7 x 99.8 cm.
 (ensemble)
77:503:1–8
Gift of 3M Co., ex-collection Louis
 Walton Sipley
(Illustrated)

214
VICTOR PREVOST
French (1820–1881)
PART OF THE IRON BRIDGE ON
EQUESTRIAN ROAD. AUGUST 17TH
1862
From: presentation portfolio ("to A.
 H. Green Esq." from V. Prevost),
 Central Park, New York, 1862, pl. 5
13.5 x 13.5 cm.
76:031:6
Museum purchase

215
VICTOR PREVOST
BRIDGE NO. 3. SEPTEMBER 23
1862
From: presentation portfolio ("to A.
 H. Green Esq." from V. Prevost),
 Central Park, New York, 1862, pl.10
Albumen print
13.9 x 13.2 cm.
76:031:11
Museum purchase

216
VICTOR PREVOST
THE EAGLE, AUGUST 30TH
1862
From: presentation portfolio ("to A.
 H. Green Esq." from V. Prevost),
 Central Park, New York, 1862, pl. 11
Albumen print
13.5 x 13.5 cm.
76:031:12
Museum purchase

217
VICTOR PREVOST
SEPTEMBER 10TH
1862
From: presentation portfolio ("to A.
 H. Green Esq." from V. Prevost),
 Central Park, New York, 1862, pl. 17
Albumen print
14.3 x 13.0 cm.
76:031:19
Museum purchase
(Illustrated)

218
VICTOR PREVOST
SHILLER MONUMENT. OCTOBER 6TH
1862
From: presentation portfolio ("to A.
 H. Green Esq." from V. Prevost),
 Central Park, New York, 1862, pl. 25
Albumen print
13.5 x 13.3 cm.
76:031:29
Museum purchase

219
HENRY RAVELL
American (1860–1930)
CHURCH BELFREY [sic] AND TILED DOMES
AQUASCALUNTES, MEXICO
ca. 1910
Gum bichromate print
26.3 x 33.5 cm.
72:196:70
Gift of Henry Trebert

220
HENRY RAVELL
[SEASCAPE]
ca. 1910
Gum bichromate print
10.5 x 15.5 cm.
74:016:4
Gift of Henry Trebert

221
HENRY RAVELL
[SEASCAPE]
ca. 1910
Gum bichromate print
10.5 x 15.5 cm.
74:016:3
Gift of Henry Trebert

222
MAN RAY [EMMANUEL RUDNITSKY?]
American (1890–1976)
[TYPEWRITER]
1920s
Gelatin silver print
25.0 x 30.1 cm.
74:140:1
Museum purchase

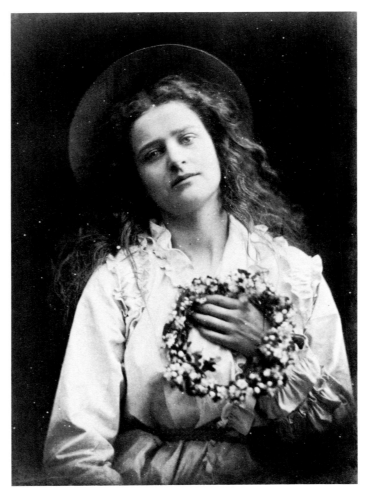

106. PETER HENRY EMERSON

223
ISAAC H. REHN
American (active 1850s, 1860s)
[UNIDENTIFIED WOMAN AND CHILDREN]
1855
Ambrotype
Half plate, 8.9 x 12.2 cm. (sight)
77:267:19
Gift of 3M Co., ex-collection Louis
 Walton Sipley

224
HENRY PEACH ROBINSON
British (1830–1901)
A STUDY
1858
Albumen print
18.6 x 24.3 cm.
75:091:1
Museum purchase

225
JULES CESAR ROBUCHON
French (active 1860s–1890s)
CHATEAU DE SAINT-MESMIN-LA-VILLE,
INTERIOR VIEW OF THE COURTYARD
ca. 1890s
From: J. Robuchon, *Paysages et*
 monuments du Poitou: St.-André-sur-
 Sèvres (Deux-Sèvres), Paris, ca. 1890
Woodburytype print
21.5 x 16.5 cm.

79:4284:1
Gift of Dr. Walter Clark

226
JULES CESAR ROBUCHON
SAINT-SERVAN (ILLE-ET-VILAINE):
THE STRAND, THE CITY FORT AND
ST.-MALO BAY: VIEW TAKEN AT LOW TIDE
FROM THE UNION HOTEL
ca. 1890s
From: J. Robuchon, *Paysages et*
 monuments de la Bretagne, Paris, n.d.,
 (ca. 1890), pl. 68
Photogravure print by P. Dujardin
16.7 x 23.0 cm.
79:4403:4
Gift of Dr. Walter Clark

227
JULES CESAR ROBUCHON
PARAME (ILLE-ET VILAINE): GENERAL VIEW
OF THE BEACH: VIEW TAKEN FROM
ROCHEBONNE POINT
ca. 1890s
From: J. Robuchon, *Paysages et*
 monuments de la Bretagne, Paris, n.d.,
 (ca. 1890), pl. 91
Photogravure print by P. Dujardin
16.9 x 22.9 cm.
79:4403:6
Gift of Dr. Walter Clark

228
DON RODAN
American (1950–)
FONZIE FUJI
1976
From: series, 35 *Views, Mt. Fuji*,
 ca. 1976
Color coupler print
7.9 x 7.8 cm.
77:398:35
Anonymous gift

229
DON RODAN
FUJI LACOSTE
1976
From: series, 35 *Views, Mt. Fuji*,
 ca. 1976
Color coupler print
7.9 x 7.8 cm.
77:398:21
Anonymous gift

230
DON RODAN
INFLATABLE FUJI
1976
From: series, 35 *Views, Mt. Fuji*,
 ca. 1976
Color coupler print
7.9 x 7.8 cm.

77:398:18
Anonymous gift

231
[MARCUS AURELIUS ROOT]
American (1808–1888)
[SELF [?] PORTRAIT]
ca. 1850s
Daguerreotype
Half plate, 11.6 x 8.8 cm. (sight)
77:259:9
Gift of 3M Co., ex-collection Louis
 Walton Sipley

232
ARTHUR ROTHSTEIN
American (1915–)
BAD LANDS, SOUTH DAKOTA
1936
Gelatin silver print
20.6 x 20.9 cm.
76:009:5
Gift of the photographer

233
ARTHUR ROTHSTEIN
FARMER AND WIFE, COLORADO
1939
Gelatin silver print
24.7 x 18.8 cm.
76:009:6
Gift of the photographer

234
[CONSTANCE SACKVILLE WEST]
British (?–1928)
[CROQUET SCENE]
1867
From: presentation album (to her sister
 from C. Sackville West), no title,
 London, 1867, fol. 18r.
Albumen prints, watercolor, montage
22.7 x 28.8 cm.
76:151:16
Museum purchase

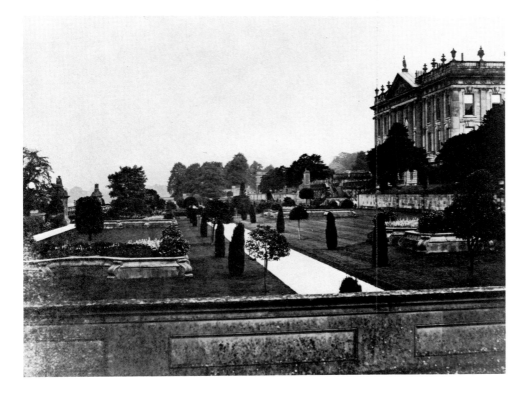

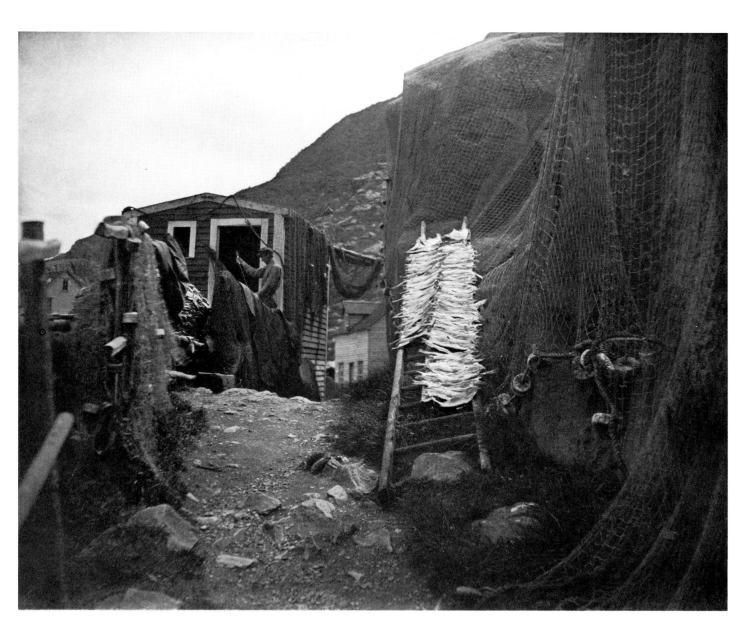

235
RICHARD SCHAEFFER
American (1949–)
SEA TORTOISE, SKY LIGHT,
IN SAN FRANCISCO
1975/1976
Gelatin silver print
19.0 x 27.6 cm.
75:143:6
Museum purchase with National
 Endowment for the Arts support

236
VICTOR SCHRAGER
American (1950–)
[STILL LIFE]
1978
Gelatin silver print
9.8 x 12.0 cm.
78:616:2
Gift of the photographer

237
GEORGE FRANCIS SCHREIBER & SONS
American (b. Germany, 1803–1892;
 firm active until 1920s)
[PORTRAIT OF A THOROUGHBRED]
1881
Salted (?) paper print, hand colored
50.0 x 70.0 cm.
77:250:1
Gift of 3M Co., ex-collection Louis
 Walton Sipley

238
STEPHEN SHORE
American (1947–)
DESERT ST., VAN HORN, TEXAS 2/20/75
1975
Color coupler print
20.2 x 24.6 cm.
77:022:3
Gift of the photographer

239
AARON SISKIND
American (1903–)
MANZINILLO (MEXICO) 9
1955
Gelatin silver print
49.8 x 37.4 cm.
77:842:51
Gift of Richard Menschel

240
AARON SISKIND
ROME 50 1963
1963
Gelatin silver print
34.0 x 26.5 cm.
77:842:35
Gift of Richard Menschel
(Illustrated)

241
AARON SISKIND
ROME 107 1973
1973
From: series, *Homage to
 Franz Kline*, 1973
24.4 x 24.1 cm.
76:311:3
Gift of the photographer

242
AARON SISKIND
[GROCERY/DELICATESSEN STORE FRONT]
1939
From: series, *Most Crowded Block in the
 World*, 1939
Gelatin silver print
14.5 x 11.8 cm.
73:084:56
Gift of the photographer
(Illustrated)

304. WEHRLI BROTHERS

243
AARON SISKIND
[STREET SCENE; 2 WOMEN AND CHILD]
1939
From: series, *Most Crowded Block in the World*, 1939
Gelatin silver print
16.0 x 11.9 cm.
73:084:0
Gift of the photographer

244
EDWARD STEICHEN
American (b. Luxembourg 1879–1973)
COLETTE
1935
Dye transfer print
23.8 x 18.8 cm.
79:2462:1
Bequest of Edward Steichen by
 direction of Joanna T. Steichen

245
EDWARD STEICHEN
FROST ON RAMBLER ROSES
1912
Gelatin silver print
19.5 x 24.5 cm.
79:2025:1
Bequest of Edward Steichen by
 direction of Joanna T. Steichen
(Illustrated)

246
EDWARD STEICHEN
GRETA GARBO
1928
Gelatin silver print
24.0 x 19.0 cm.
78:2176:21
Bequest of Edward Steichen by
 direction of Joanna T. Steichen

247
EDWARD STEICHEN
GEORGE GERSHWIN
1927
Gelatin silver print
42.0 x 34.0 cm.
79:2179:1
Bequest of Edward Steichen by
 direction of Joanna T. Steichen

248
EDWARD STEICHEN
GERTRUDE LAWRENCE
1928
Gelatin silver print
24.0 x 19.0 cm.
79:2232:1
Bequest of Edward Steichen by
 direction of Joanna T. Steichen

249
EDWARD STEICHEN
SELF PORTRAIT
ca. 1920
Palladium and ferro-prussiate print
24.3 x 19.5 cm.
79:2502:1
Bequest of Edward Steichen by
 direction of Joanna T. Steichen

250
EDWARD STEICHEN
[PHOTOGRAPHIC DESIGN FOR STEHLI SILKS]
1926
Gelatin silver print
19.0 x 24.0 cm.
79:2421:3
Bequest of Edward Steichen by
 direction of Joanna T. Steichen

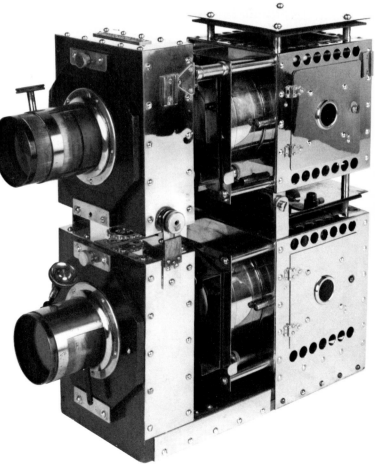

327. A. D. HANDY

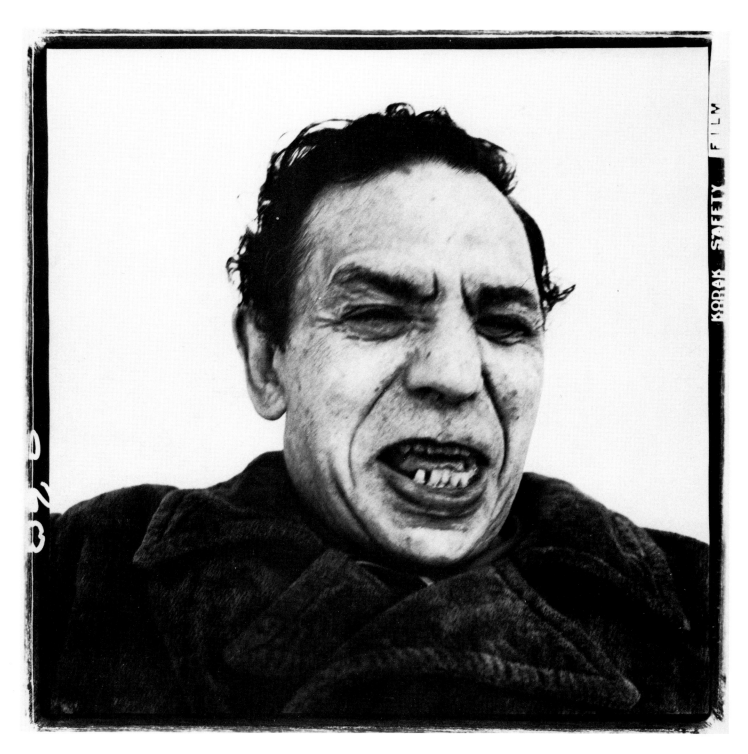

251
EDWARD STEICHEN
[PORTRAIT OF UNIDENTIFIED WOMAN]
ca. 1911
Modern color coupler reproduction of
 autochrome plate, 1981, courtesy
 Eastman Kodak Co.
18.0 x 13.0 cm.
81:298:1MP
Autochrome gift of Joanna T. Steichen
(Illustrated)

252
CARLA STEIGER-MEISTER
American (1951–)
[CHAIR]
1977
Color coupler print
23.6 x 23.3 cm.
78:837:1
Gift of the photographer

253
RALPH STEINER
American (1899–)
FORD HEADLIGHT AND WHEEL
1929
Gelatin silver print
24.0 x 19.0 cm.
79:106:1
Museum purchase

254
KARL STRUSS
American (1886–)
[PORTRAIT OF UNIDENTIFIED WOMAN]
1917
Hess-Ives print
23.7 x 19.7 cm.
79:4256:1
Gift of the photographer

255
STEVE SZABO
American (1940–)
WYOMING
1974
Platinum print
19.5 x 24.5 cm.
76:126:1
Museum purchase with National
 Endowment for the Arts support

256
AUGUSTUS J. J. THIBAUDEAU
American (active 1900–1915)
[URBAN RIVER VIEW]
ca. 1910
Platinum print
33.3 x 26.1 cm.
80:178:10
Gift of Marie Thibaudeau

257
AUGUSTUS J. J. THIBAUDEAU
[FEMALE PORTRAIT]
ca. 1910
Platinum print
34.0 x 25.8 cm.
80:178:7
Gift of Marie Thibaudeau

258
CAPTAIN LINNEAUS TRIPE
British (active 1855–1858)
[APPROACH TO THE GREAT TEMPLE,
MADURAI, INDIA]
ca. 1855
Salted paper print
29.0 x 37.5 cm.
78:446:1
Museum purchase
(Illustrated)

259
U.S. INSTANTANEOUS PHOTOGRAPHIC CO.
American (firm active 1880s)
THE DEATH-BEDROOM AS IT APPEARED ON
THE MORNING GENERAL GRANT DIED,
JULY 23, 1885
1885
From: U.S. Inst. Photo. Co., *Seven Mile
 Funeral Cortege of Genl. Grant in New
 York, Aug. 8, 1885*, Boston, 1885,
 no. 11

Albumen print
24.6 x 29.3 cm.
74:027:6
Museum purchase

260
U.S. INSTANTANEOUS PHOTOGRAPHIC CO.
A VIEW FROM THE RESERVOIR (FORTIETH
STREET)
1885
From: U. S. Inst. Photo. Co., *Seven
 Mile Funeral Cortege of Genl. Grant
 in New York, Aug. 8, 1885*, Boston,
 no. 41
Albumen print
29.4 x 19.1 cm.
74:027:23
Museum purchase

261
U.S. INSTANTANEOUS PHOTOGRAPHIC CO.
THE NEW JERSEY DIVISION...
PASSING UP BROADWAY
1885
From: U. S. Inst. Photo. Co., *Seven
 Mile Funeral Cortege of Genl. Grant
 in New York, Aug. 8, 1885*, Boston,
 no. 194
Albumen print
24.7 x 29.2 cm.
74:027:135
Museum purchase

262
JERRY N. UELSMANN
American (1934–)
ANSEL BY JERRY
1970
Gelatin silver print
19.5 x 24.5 cm.
77:063:1
Gift of the photographer

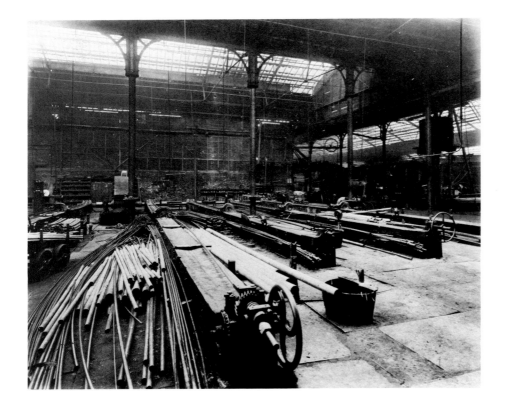

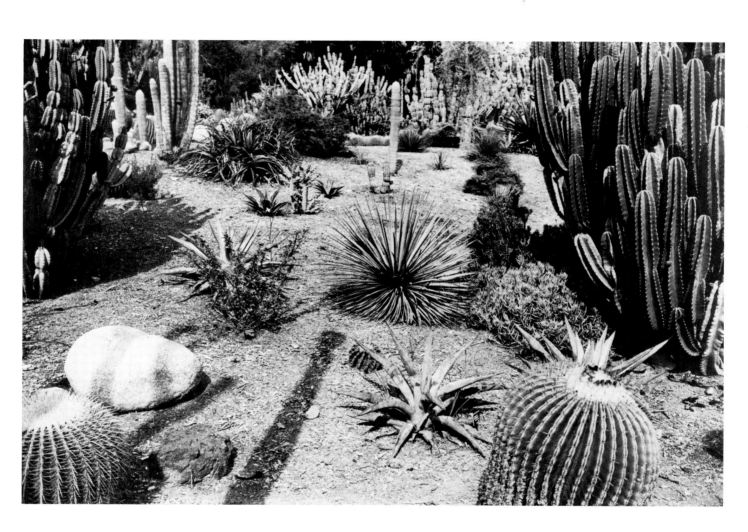

122. JOHN GOSSAGE

263
IRVING UNDERHILL
American (active New York City,
 1910s, 1920s)
[CABLE CONNECTORS]
ca. 1915
Modern gelatin silver print by Michaela
 Allan Murphy (from original
 negative), 1980
13.8 x 18.7 cm.
79:1994:285MP
Original negative gift of Fred
 Lowenfels

264
IRVING UNDERHILL
[OPEN END WRENCHES]
ca. 1915
Modern gelatin silver print by Michaela
 Allan Murphy (from original
 negative), 1980
18.8 x 13.9 cm.
79:1994:313MP
Original negative gift of Fred
 Lowenfels

265
IRVING UNDERHILL
[PALM WRENCH]
ca. 1915
Modern gelatin silver print by Michaela
 Allan Murphy (from original
 negative), 1980
12.9 x 18.0 cm.
79:1994:361MP
Original negative gift of Fred
 Lowenfels

266
IRVING UNDERHILL
[WRENCH SET]
ca. 1915
Modern gelatin silver print by
 Michaela Allan Murphy (from
 original negative), 1980
13.9 x 18.8 cm.
79:1994:207MP
Original negative gift of Fred
 Lowenfels

267
UNIDENTIFIED PHOTOGRAPHER
American
[HOUSE AND GARDEN]
ca. 1850s
Daguerreotype
Full plate, 16.4 x 21.6 cm.
77:420:6
Gift of 3M Co., ex-collection Louis
 Walton Sipley

268
UNIDENTIFIED PHOTOGRAPHER
American
[PORTRAIT OF MRS. JOHN B. MYERS]
ca. late 1850s
Albumen affixed to glass
 ("Ivorytype"), hand colored
21.6 x 16.5 cm.
77:788:1
Gift of 3M Co., ex-collection Louis
 Walton Sipley

269
UNIDENTIFIED PHOTOGRAPHER
American

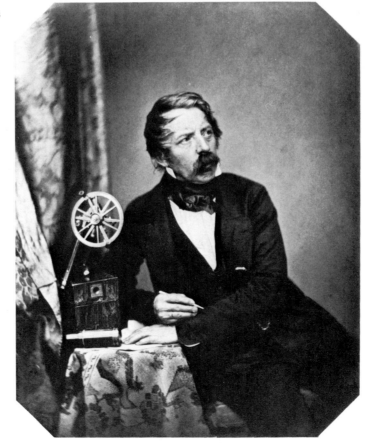

STEAM ENGINE (CATASANQUA),
1500 HORSE POWER
Early 1860s
Albumen print
18.7 x 13.3 cm.
77:837:2
Gift of 3M Co., ex-collection Louis
 Walton Sipley

270
UNIDENTIFIED PHOTOGRAPHER
American
ALHAMBRA-GRANADA, SPAIN
1891
Gelatin silver print
8.0 x 8.4 cm. (Kodak #2)
78:1306:212
Anonymous gift

271
UNIDENTIFIED PHOTOGRAPHER
American
[COBBLESTONE STREET]
1890s
Gelatin silver print
8.1 x 8.4 cm. (Kodak #2)

78:1306:267
Anonymous gift

272
UNIDENTIFIED PHOTOGRAPHER
American
FROM WINDOW OF THE TOWER OF THE
CAPTIVE, ALHAMBRA, GRANADA
1891
Gelatin silver print
8.1 x 8.5 cm. (Kodak #2)
78:1306:243
Anonymous gift

273
UNIDENTIFIED PHOTOGRAPHER
American
[GIANT LILY PADS]
1890s
Gelatin silver print
6.4 cm. dia. (Kodak #1)
78:1306:170
Anonymous gift

274
UNIDENTIFIED PHOTOGRAPHER
American
[LANDSCAPE WITH STATUE]
1890s
Gelatin silver print
6.4 cm. dia. (Kodak #1)
78:1306:9
Anonymous gift

275
UNIDENTIFIED PHOTOGRAPHER
American
[LOCOMOTIVE]
1890s
Cyanotype print
8.8 cm. dia.
78:1306:320
Anonymous gift

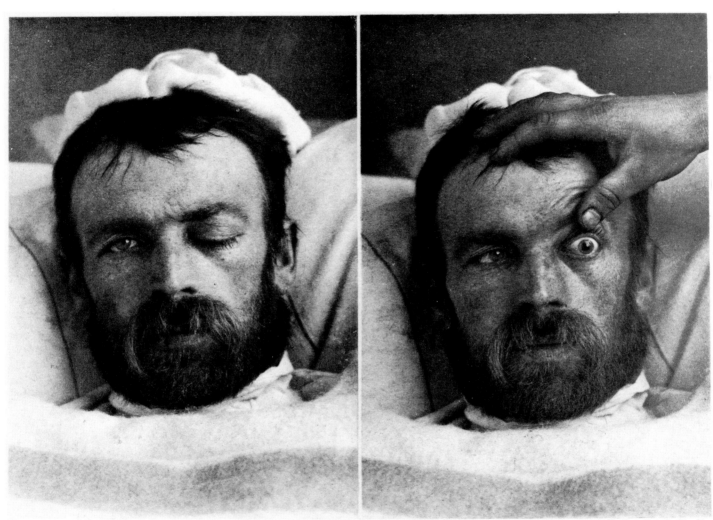

Verlag von Julius Springer, Berlin N. Heliogr. Meisenbach Riffarth & Co. Berlin.

73. HEINRICH CURSCHMANN

276
UNIDENTIFIED PHOTOGRAPHER
American
DESERT: JOHN (?) AT HISPERIA, CALIFORNIA
1890
Gelatin silver print
8.8 cm. dia. (Kodak #2)
78:1306:101
Anonymous gift

277
UNIDENTIFIED PHOTOGRAPHER
American (?)
[SNAPSHOTS OF CHINESE STREET LIFE]
ca. 1900
From: album, *Views in China*, n.p., n.d.,
 (ca. 1900), fol. 5v. 6r.
Gelatin silver prints
316 x 27.3 cm. (folio)
74:185:60–73
Museum purchase

278
UNIDENTIFIED PHOTOGRAPHER
British
ISLE OF WIGH, BONCHURCH
ca. 1870s
Chromolithographic print
16.4 x 22.3 cm.
77:307:2
Gift of 3M Co., ex-collection Louis
 Walton Sipley

279
UNIDENTIFIED PHOTOGRAPHER
British
[ST. JEROME IN STUDY]
ca. late 1850s
Albumen print
11.1 x 8.8 cm.
76:279:1
Museum purchase

280
UNIDENTIFIED PHOTOGRAPHER
French
PALMYRE LIGHTHOUSE (GIRONDE)
ca. 1883
From: Léonce Reynaud (ed.), *Les
 Travaux publics de la France*, vol. 5,
 (E. Allard, *Phares et Balises*), Paris,
 1883, pl. 36
Collotype print
32.7 x 24.1 cm.
78:112:36
Museum purchase
(Illustrated)

281
UNIDENTIFIED PHOTOGRAPHER
French
MEMPHIS: SAKKARA
ca. 1893

From: François Auguste Ferdinand
 Mariette-Bey, *Voyage dans la
 Haute-Egypte*, 2d. ed. [?], Paris,
 1893, unn.
Photogravure print by Goupil, Paris
18. 3 x 23.7 cm.
79:2895:10
Museum purchase

282
UNIDENTIFIED PHOTOGRAPHER
French
THEBES: LUXOR
ca. 1893
From: François Auguste Ferdinand
 Mariette-Bey, *Voyage dans la
 Haute-Egypte*, 2d. ed. [?], Paris,
 1893, unn.
Photogravure print by Goupil, Paris

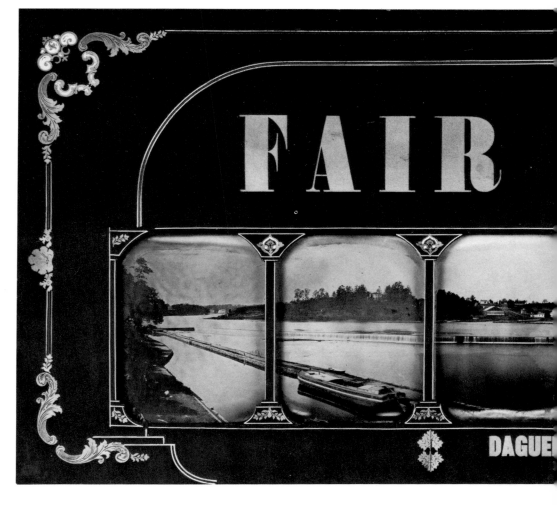

17.4 x 24.3 cm.
79:2895:7
Museum purchase

283
UNIDENTIFIED PHOTOGRAPHER
French
THEBES: MEDINET-HABU
ca. 1893
From: François Auguste Ferdinand
 Mariette-Bey, *Voyage dans la
 Haute-Egypte*, 2d. ed. [?], Paris,
 1893, unn.
Photogravure print by Goupil, Paris
19.5 x 24.2 cm.
79:2895:1
Museum purchase

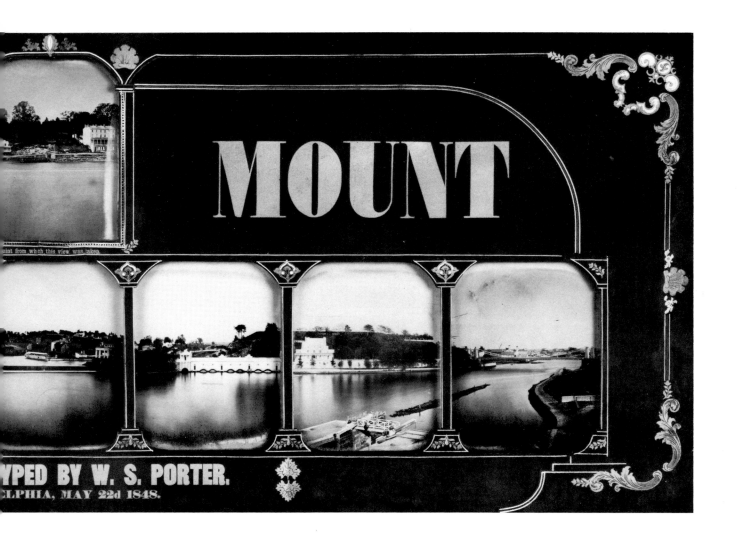

284

UNIDENTIFIED PHOTOGRAPHER

French

DIJON: TOMB OF PHILIPPE POT

ca. 1863

From: Baron I. Taylor, *Voyages
pittoresques et romantiques dans
l'ancienne France*, (*Bourgogne*, I),
Paris, 1863, pl. 74

Photolithographic print by J. & A.
Lemercier, Paris; Poitevin process

25.0 x 36.3 cm.

79:4184:75

Museum purchase

285

UNIDENTIFIED PHOTOGRAPHER

French

[ACADEMIE (ANGELICA?)]

ca. 1851

Daguerreotype

Stereograph, 8.1 x 17.1 cm. (ensemble)

77:246:4

Gift of 3M Co., ex-collection Louis
Walton Sipley

286

UNIDENTIFIED PHOTOGRAPHER

French

[SNAPSHOTS OF AIRCRAFT AND
MODEL AIRPLANES]

1910

From: album, *Paris Aviation*, Paris,
1910, nos. 119–126

Gelatin silver prints

3.9 x 5.5 cm. (each image)

76:044:31,32

Museum purchase

(Illustrated)

287

UNIDENTIFIED PHOTOGRAPHER

German (?)

THE CASTLE OF NUREMBERG

ca. 1870

Albumen print

20.6 x 25.7 cm.

78:1773:25

Gift of 3M Co., ex-collection Louis
Walton Sipley

288

UNIDENTIFIED PHOTOGRAPHER

German (?)

[LANDSCAPE WITH WHEEL BARROW]

ca. 1870

Albumen print

18.7 x 25.2 cm.

78:1773:18

Gift of 3M Co., ex-collection Louis
Walton Sipley

289

UNIDENTIFIED PHOTOGRAPHER

Japanese

A MILLINER

ca. 1890s

Albumen print, hand colored

21.2 x 27.4 cm.

74:034:18

Museum exchange

290

UNIDENTIFIED PHOTOGRAPHER

Japanese

NEW YEAR DEILL (sic) OF
JAPANESE FIRE BRIGADE

ca. 1890s

Albumen print, hand colored

26.2 x 19.9 cm.

74:034:16

Museum exchange

291

UNIDENTIFIED PHOTOGRAPHER

Japanese

SUMA. NEAR KOBE

ca. 1890s

Albumen print, hand colored

21.4 x 27.7 cm.

74:034:19

Museum purchase

(Illustrated)

292

UNIDENTIFIED PHOTOGRAPHER

Japanese

[TWO WOMEN IN GARDEN]

ca. 1890s

Albumen print, hand colored

26.5 x 20.2 cm.

74:034:45

Museum exchange

293

UNIDENTIFIED PHOTOGRAPHER

Swiss

ANNA MARIA BERGDORF and MAGDALENA
BERGDORF [POLICE (?) IDENTIFICATION
PORTRAITS]

1853

From: album, *Portraits Photographies des
Heimathloses*, n.p., n.d., (1853)

Lithographic prints from photographs
by unidentified lithographer

19.5 x 15.0 cm. (each folio)

76:041:130,131

Museum purchase

294

**SAMUEL VAN LOAN and
JOHN JABEZ EDWARD MAYALL**

American (b. England, active
1844–1854) and British
(1810–1901)

[PORTRAITS OF PROFESSOR MARTIN BOYE &
MRS. MARTIN BOYE]

1846

Daguerreotype

Quarter plates, 7.9 x 5.9 cm. (each by
sight)

77:259:7,8

Gift of 3M Co., ex-collection Louis
Walton Sipley

295

KARL VANEK

German (active 1930s)

MCDONALD SAYS TO HIMSELF: BECOMING A
FATHER WASN'T DIFFICULT

1935

From: *AIZ*, April 25, 1935, p. 257

Photomechanical halftone of
photomontage

39.0 x 27.3 cm.

76:076:5

Museum purchase

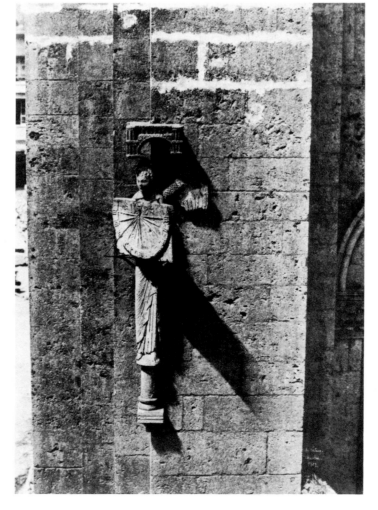

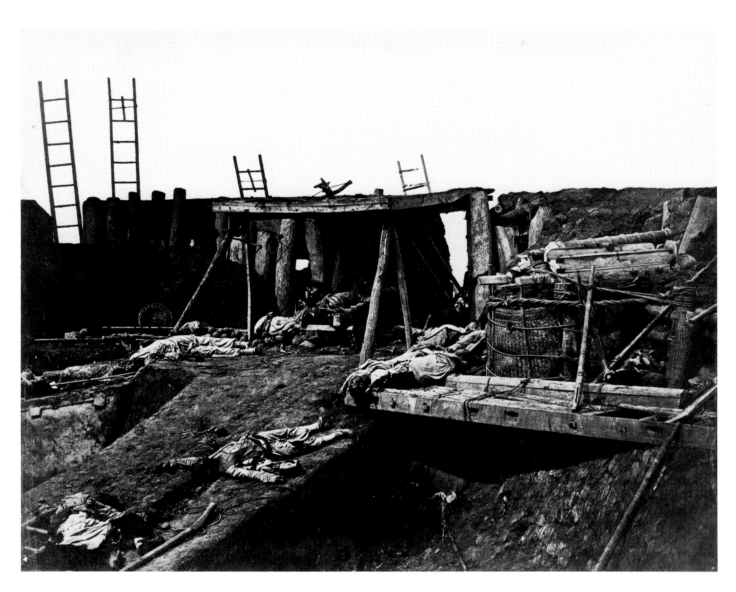

36. FELICE BEATO

296
SAMUEL LEON WALKER
American (1802–1874)
[PORTRAIT OF ARTIST'S DAUGHTER]
ca. 1852
Daguerreotype
Quarter plate, 8.9 x 7.5 cm. (sight)
78:150:4
Museum purchase

297
SAMUEL LEON WALKER
[PORTRAIT OF UNIDENTIFIED WOMAN]
ca. early 1850s
Daguerreotype
Half plate, 12.4 x 9.3 cm. (sight)
78:150:1
Museum purchase

298
J. A. WARWICK
British (active 1860s)
THE CONSERVATORY
ca. 1860
From: J. A. Warwick, *Chatsworth
 Photographs*, London, n.d., (ca.
 1860), unn.
Albumen print
12.1 x 17.4 cm.
77:854:30
Museum purchase

299
J. A. WARWICK
FERNS IN THE CONSERVATORY
ca. 1860
From: J. A. Warwick, *Chatsworth
 Photographs*, London, n.d., (ca.
 1860), unn.
Albumen print
12.0 x 17.3 cm.
77:854:29
Museum purchase

300
J. A WARWICK
[STATUE OF] HEBE BY CANOVA
ca. 1860
From: J. A. Warwick, *Chatsworth
 Photographs*, London, n.d., (ca.
 1860), unn.
Albumen print
17.3 x 12.0 cm.
77:854:24
Museum purchase

301
WILLIAM WEGMAN
American (1943–)
BEFORE/ON/AFTER: PERMUTATIONS
1972
Gelatin silver prints
32.9 x 07.2 cm.
78:713:1–7
Museum purchase with National
 Endowment for the Arts support

302
WEHRLI BROTHERS
Swiss (active 1890s)
FINDELEN AND MATTERHORN
ca. 1890s
Gelatin silver print
21.9 x 16.3 cm.
77:306:9
Gift of 3M Co., ex-collection Louis
 Walton Sipley

303
WEHRLI BROTHERS
GRINDEWALD: WETTERHORN
ca. 1890s
Gelatin silver print
16.3 x 21.8 cm.
77:306:3
Gift of 3M Co., ex-collection Louis
 Walton Sipley

304
WEHRLI BROTHERS
MONTE ROSA SEEN FROM GORNERGRAT
ca. 1890s
Gelatin silver print
16.5 x 21.9 cm.
77:306:12
Gift of 3M Co., ex-collection Louis
 Walton Sipley
(Illustrated)

305
WEHRLI BROTHERS
[LANDSCAPE IN SWITZERLAND]
ca. 1890s
Gelatin silver print
15.9 x 21.8 cm.
77:306:4
Gift of 3M Co., ex-collection Louis
 Walton Sipley

306
J. WENINGER
Belgian (?) (active 1850s)
TIA AND ADINE KORFF
1850
Daguerreotype
Quarter plate, 10.0 x 7.6 cm. (sight)
79:259:10
Gift of 3M Co., ex-collection Louis
 Walton Sipley

307
EDWARD WESTON
American (1886–1958)
[PORTRAIT OF SADAKICHI HARTMANN]
ca. 1917
Platinum print
24.3 x 18.9 cm.
77:786:1
Gift of 3M Co., ex-collection Louis
 Walton Sipley

286. UNIDENTIFIED PHOTOGRAPHER

308
CLARENCE WHITE
American (1871–1925)
ON THE STAIRS
1898
Platinum print
19.5 x 8.7 cm.
77:212:1
Gift of 3M Co., ex-collection Louis
 Walton Sipley

309
JAMES LEON WILLIAMS
British (1852–1932)
AT SHOTTERY BROOK
ca. 1892
From: J. L. Williams, *The Homes and
 Haunts of Shakespeare*, London, 1892,
 facing p. 44
Photogravure print, with hand work
23.5 x 18.3 cm.
76:021:21
Museum purchase
(Illustrated)

310
JAMES W. WILLIAMS
American (active Philadelphia, 1850s)
[PORTRAIT OF LOUIS R. FISKE?]
ca. late 1850s
Albumen affixed to glass
 ("Ivorytype"), hand colored
20.2x 16.2 cm.
77:788:2
Gift of 3M Co., ex-collection Louis
 Walton Sipley

311
GEORGE WASHINGTON WILSON
British (1823–1893)
THE SILVER STRAND, LOCH KATRINE
ca. 1875–1880
Albumen print
19.4 x 29.3 cm.
77:193:1
Gift of 3M Co., ex-collection Louis
 Walton Sipley

312
A. ADAMS & CO. LTD.
London, England
ADAMS REFLEX CAMERA
1930
Folding reflex camera, tropical model
Taylor Hobson "Aviar" 5 1/2 inch
 lens, f/4.5
2 1/2 x 3 1/2 in. format
74:028:3131
Museum purchase

313
AGFA–GEVAERT AG.
Munich, Germany
AGFAMATIC MOTOR 901 E CAMERA
1978
110 cartridge with built–in
 motor–drive
Color–Apotar lens, 27 mm. f/6.3
13.0 x 17.0 mm. format
81:791:1
Gift of Agfa-Gevaert Inc., USA

314
ASAHI OPTICAL CO. LTD.
Tokyo, Japan
PENTAX AUTO 110 CAMERA
1977
Single lens reflex camera
25 mm. f/2.8 lens
13.0 x 17.0 mm. format
79:4276:1
Gift of Asahi Optical Co. Ltd.

315
ASAHI OPTICAL CO. LTD.
Tokyo, Japan
ASAHI PENTAX 6x7 CAMERA
1974
Single lens reflex camera
Takumar lens 75 mm. f/45
6.0 x 7.0 cm. format
74:028:3083
Gift of Asahi Optical Co. Ltd.

316
BAUSCH & LOMB OPTICAL CO.
Rochester, New York
3B PORTRAIT LENS f/2.2
ca. 1890
Petzval portrait lens
14 1/2 in. focal length
81:794:1
Gift of Bausch & Lomb Inc.

317
BELL & HOWELL
Chicago, Illinois
70 DR CAMERA
1975
16 mm. motion picture camera
Canon lens, 25 mm. f/1.4
7.5 x 10.0 mm. format
81:793:1
Gift of Bell & Howell Inc.

318
BELL & HOWELL
Chicago, Illinois
STANDARD CINEMATOGRAPH CAMERA
ca. 1920
35 mm. cine camera
4 lens turret
35 mm. format cine silent
81:790:1
Gift of James Sibley Watson, Jr.

319
W. BERMPOHL
Berlin, Germany
DR. MIETHE'S 3–COLOR CAMERA
ca. 1906
Sequencing–type 3–color separation
 camera
73.0 x 88.0 mm. format
77:415:210
Gift of 3M Co., ex-collection Louis
 Walton Sipley

320
LEON BLOCH
Paris, France
LE PHYSIOGRAPHE [CAMERA]
1896
Binocular form deceptive angle stereo
 camera
2 Krauss Tessar lenses, 51 mm. f/6.3
45.0 x 107.0 mm. format glass plates in
 magazine
74:028:3297
Museum exchange

321. DOUGLAS CROCKWELL, SR.

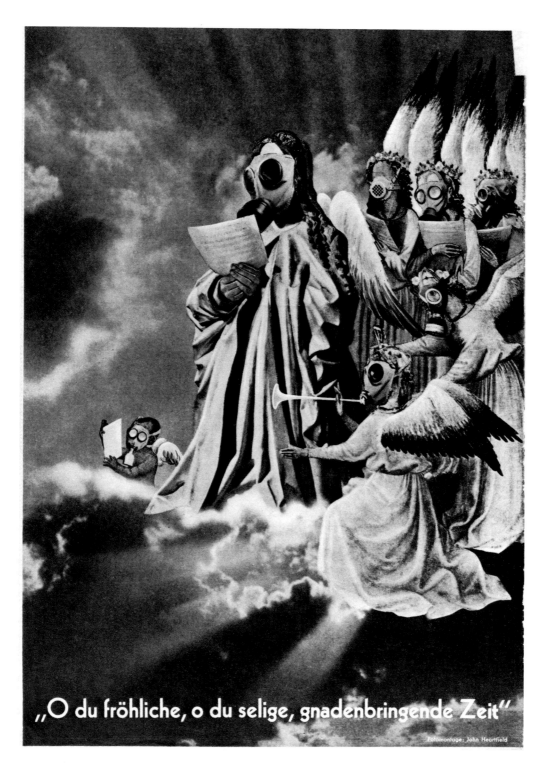

„O du fröhliche, o du selige, gnadenbringende Zeit"

Fotomontage: John Heartfield

129. JOHN HEARTFIELD

321
DOUGLAS CROCKWELL, SR.
Glens Falls, New York
CROCKWELL PAN STEREO CAMERA
1955
Stereoscopic panoramic camera
25 mm. f/3.2 lens
14.0 x 128.0 mm. format
81:062:2
Gift of Mrs. Douglas Crockwell, Sr.
(Illustrated)

322
EASTMAN KODAK COMPANY
Rochester, New York
EKTRA CAMERA
1941
35 mm. rangefinder camera outfit in
 fitted case
50 mm. f/1.9 lens and others
24.0 x 36.0 mm. format
80:096:1
Anonymous gift

323
EASTMAN KODAK COMPANY, [et al.]
Rochester, New York
LUNAR ORBITER CAMERA
1965
Optical/electronic orbiting
 photographic system
Bausch & Lomb 24 in. f/5.6 lens and
 Schneider Xenator 5 in. f/2.8 lens
5.0 x 6.0 cm. format
81:795:1
Gift of George Marusick

324
GAGY
Milan, Italy
MINI-SUB CAMERA
ca. 1965
Self-contained 35 mm. underwater
 camera
35 mm. f/9.5 lens
24.0 x 36.0 mm. format
74:028:3300
Museum purchase

325
GOLDMANN
Vienna, Austria
GOLDMANN UNIVERSAL STEREO
DETECTIVE CAMERA
ca. 1893
Dry plate stereo camera

E. Français, Paris, 110 mm. f/8 lens
 [approx.]
6.0 x 8.0 cm. [approx.], stereo pair
 format
78:1281:1
Museum purchase

326
E. GUERIN ET CIE
Paris, France
LE FURET [CAMERA]
1923
35 mm. camera
Hermagis anastigmat lens,
 40 mm. f/4.5
24.0 x 36.0 mm. format
74:028:3245
Museum exchange

327
A. D. HANDY
Boston, Massachusetts
[PROJECTOR]
ca. 1910
Double dissolving slide projector
 (acetyline illumination)
Bausch & Lomb projection lenses,
 16 in. f/7 [approx.]
3 x 3 in. format
78:1063:1
Gift of 3M Co., ex-collection Louis
 Walton Sipley
(Illustrated)

328
W. & S. JONES
London, England
[CAMERA OBSCURA]
ca. 1750
Camera obscura
24 in. [approx.] biconvex lens
12 x 18 in. [approx.] drawing area
77:415:36
Gift of 3M Co., ex-collection Louis
 Walton Sipley
(Illustrated)

329
KONISHIROKU PHOTO INDUSTRY CO. LTD.
Tokyo, Japan
C-35 CAMERA
1978
Self-focusing 35 mm. camera
Hexanon lens, 38 mm. f/2.8
24.0 x 36.0 mm. format
78:915:1
Gift of Konica Corp.

330
E. KRAUSS
Paris, France
PHOTOREVOLVER CAMERA
1921
Hand-held miniature camera with
 plate magazine
Krauss-Zeiss Tessar lens, 40 mm. f/4.5
18.0 x 35.0 mm. format
74:028:3157
Museum exchange

331
ERNST LEITZ
Wetzlar, Germany
LEICA MODEL B CAMERA
1929
35 mm. camera
Elmar lens, 50 mm. f/3.5
24.0 x 36.0 mm. format
74:028:3346
Museum purchase

332
ERNST LEITZ
Wetzlar, Germany
LEICA MODEL C CAMERA
1930
35 mm. camera
Elmar lens, 50 mm. f/3.5
24.0 x 36.0 mm.
74:028:3027
Museum purchase

333
ERNST LEITZ
Wetzlar, Germany

LEICA GG 250 CAMERA
1935
35 mm. camera with 250 exposure
 capacity
Elmar lens, 50 mm. f/3.5
24.0 x 36.0 mm. format
74:037:2926
Museum purchase

334
W. and W. H. LEWIS
New York, New York
[DAGUERREOTYPE CAMERA]
ca. 1851
Daguerreotype camera
C. C. Harrison lens, 12 in. f/4
 [approx.]
Half-plate, 4 1/2 x 6 1/2 in. [approx.]
 format
78:463:1
Gift of 3M Co., ex-collection Louis
 Walton Sipley

335
LINHOF AG.
Munich, Germany
TECHNORAMA CAMERA
1976
Extreme wide-angle panoramic camera
Schneider super angulon lens,
 90 mm. f/5.6
6.0 x 17.0 cm. format
80:045:1
Gift of Linhof AG. and Schneider AG.

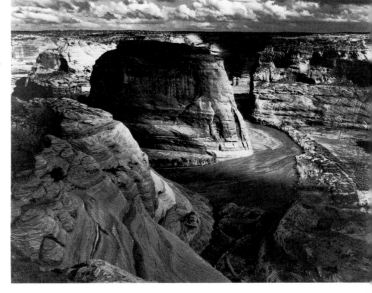

3. ANSEL ADAMS

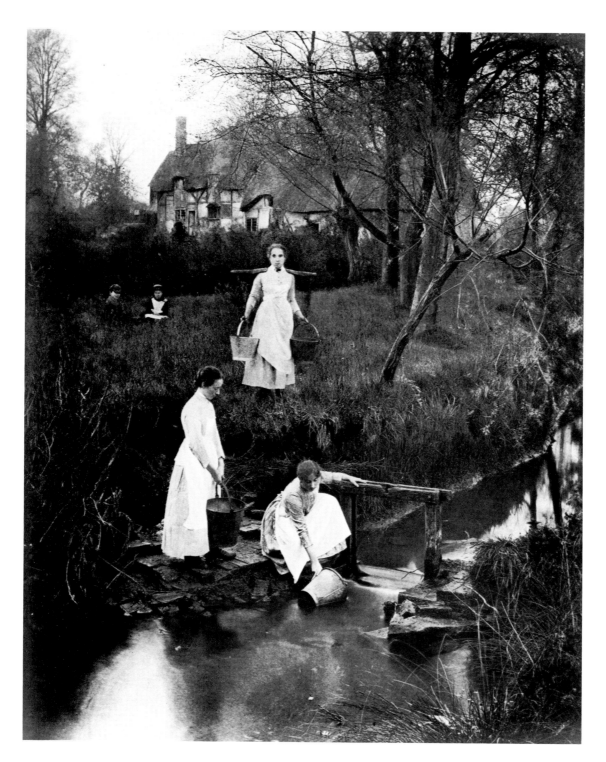

309. JAMES LEON WILLIAMS

336
MOLLIER
Paris, France
LE CENT VUES [CAMERA]
ca. 1926
35 mm. 100-exposure camera, half
 frame
Hermagis anastigmat lens,
 40 mm. f/3.5
18.0 x 24.0 mm. format
74:028:3248
Museum exchange

337
OESTEREICHES TELEPHONWERKE AG.
Vienna, Austria
AMOURETTE [CAMERA]
1925
35 mm. film in special double casette
Double Miniscope lens, 35 mm. f/6.3
24.0 x 30.0 mm. format
74:028:3259
Anonymous gift

338
PERKEN, SON & CO. LTD.
London, England
[VIEW CAMERA]
ca. 1900
Folding view camera
Achromatic landscape lens, 10 inch
 f/15 [approx.]
Full plate, 6 1/2 x 8 1/2 in., format
74:028:3086
Museum purchase
(Illustrated)

339
PLAUBEL & CO.
Frankfurt, Germany
STEREO MAKINA CAMERA
ca. 1925
Folding stereo camera
2 Plaubel Anticomar lenses, 90 mm.
 f/2.9
6.0 x 13.0 cm. format

74:028:3308
Museum purchase

340
POLAROID CORP.
Cambridge, Massachusetts
SX-70 SONAR ONE-STEP CAMERA
1977
Autofocusing Instant camera
110 mm. f/8 lens [approx.]
3 1/8 in. square format
80:095:1
Gift of Polaroid Corp.

341
ROLLEI GMBH
Braunschweig, Germany
ROLLEIFLEX SLX CAMERA
1976
Single lens reflex camera with built-in
 motor drive
Zeiss Planar lens, 80 mm. f/2.8
6.0 x 6.0 cm. format
78:1519:1
Gift of Rollei USA

342
USINE MAX ROTH
Valeyres s/ Montagny, Switzerland
MEMOPRINT CAMERA
1975
One-shot color camera, with viewer
Zeiss Sonnar lens, 150 mm. f/4
40.0 x 55.0 mm. format
79:1742:1
Gift of Zelacolor Systems
 Establishment

343
SIGRISTE
Paris, France
SIGRISTE STEREO CAMERA
ca. 1905
Magazine dry plate stereo camera
2 Voigtlander Heliar lenses, 85 mm.
 f/4.5
6.0 x 13.0 cm. format
74:037:2810
Museum exchange

344
SOVIET STATE CAMERA INDUSTRY
Unidentified city, USSR
INDUSTAR-50 FT-2 CAMERA
ca. 1960
Swinging-lens panoramic camera
50 mm. f/5 lens
24.0 x 110.0 mm. format
74:028:3342
Museum purchase

345
SOVIET STATE CAMERA INDUSTRY
Unidentified city, USSR
HORIZONT CAMERA
1965
Swinging-lens panoramic camera
28 mm. f/2.8 lens
24.0 x 58.0 mm. format
74:028:3108
Museum purchase

346
THIRD MEDIA ENTERPRISES INC.
Upton, California
CYCLO-PAN 70 CAMERA
1974
360 degree panoramic camera
Schneider Symmar lens, 100 mm. f/5.6
70.0 x 1000.0 mm. (for 360 degree pan)
 format
78:1600:6
Museum purchase

347
UNIDENTIFIED MANUFACTURER
USA
[STEREO CAMERA]
ca. 1860
Wet-plate stereo camera
2 Harrison & Schnitzer "Globe" lenses,
 5 in. f/30 [approx.]
4 x 5 inch, stereo pair format
77:112:1
Gift of 3M Co., ex-collection Louis
 Walton Sipley

348
URBAN MOTION-PICTURE INDUSTRIES
New York, New York
SPIROGRAPH PROJECTOR
1923
Motion picture projector for images on
 a flexible disk 10 in. dia.
4 x 5 mm. format
81:056:1
Gift of S. Franklin Spira

349
VEGA SA.
Geneva, Switzerland
TELEPHOTO-VEGA CAMERA
1901
Long focus view camera with folded
 light path
100 cm. f/12 lens [approx.]
17.0 x 24.0 cm. format
75:1371:7
Museum exchange
(Illustrated)

350
VOIGTLANDER & SON AG.
Braunschweig, Germany
ROLLFILM 6.5 X 11 CAMERA
1927
Folding roll-film camera
Voigtlander Skopar lens, 114 mm. f/4.5
6.5 x 11 cm. format
81:043:1
Gift of John F. Scharffenberger

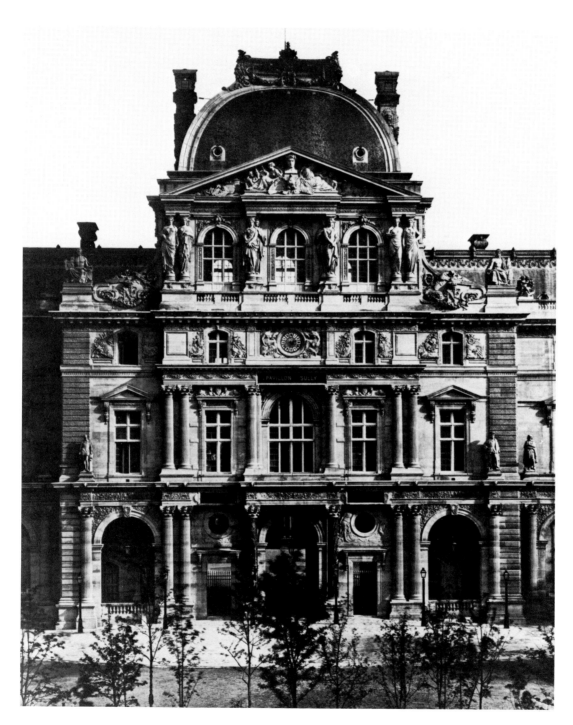

28. EDOUARD–DENIS BALDUS

ACKNOWLEDGEMENTS

Without the cooperation of many individuals, this exhibition and catalogue
would not have been possible: Andrew Eskind, Director of Interdepartmental
Services, for help in retrieval; Rick Hock and Caroline Zaft of the Exhibitions
Department for mounting the show; Ann McCabe and Jennifer Loynd of the
Office of Registrar for assistance in tracing provenances and sources; Grant
Romer and Peter Mustardo of the Conservation Laboratory for seeing that the
works in the show were displayed with the care they should be given; Linda
McCausland and Barbara Galasso of Photographic Services for recording the
works, Daniel Meyers of the Development Office, Susan Kramarsky, and
Paulette Wilson for assistance in preparing the catalogue; Christine Hawrylak
for publicity; Morgan Wesson and Dr. Rudolf Kingslake for help in researching
the equipment section; David Wooters, Assistant Archivist, and Adam Wein-
berg, VSW Intern, for assistance in research and verification of information; and,
for various kinds of support, Judy Bloch, Marta Podhorrecki, Jane Weller, Jane
Stark, Seymour Nusbaum and his staff. We are also indebted to Joseph Watson
for his designs for posters and the catalogue. While under rather severe time
limitations, all have graciously and unstintingly contributed to the realization of
the exhibition.

R.A.S., M.E, & P.C.

THIS CATALOG WAS DESIGNED BY JOE A. WATSON
AND SET IN GARAMOND AND NEWS GOTHIC BOLD
BY THE ROCHESTER MONOTYPE CORPORATION.

IT WAS PRINTED BY ROCHESTER LITHOGRAPHICS &
BOUND BY RIVERSIDE BINDERY